NORTHEAST OHIO
HIGH SCHOOL
FOOTBALL RIVALRIES

NORTHEAST OHIO
HIGH SCHOOL
FOOTBALL RIVALRIES

|||||||||||||||||||||| A HISTORY ||||||||||||||||||||||

VINCE McKEE

FOREWORD BY STATE CHAMPIONSHIP COACH
CHUCK KYLE OF ST. IGNATIUS

THE
History
PRESS

Published by The History Press
Charleston, SC
www.historypress.com

Front cover, top left: Julie Spisak Herzog; *top center*: Julie Spisak Herzog; *top right*: Julie Spisak Herzog; *bottom*: Julie Spisak Herzog.
Back cover: Andy Fowkes; *insert*: Julie Spisak Herzog.

First published 2022

Manufactured in the United States

ISBN 9781467152839

Library of Congress Control Number: 2022936604

Notice: The information in this book is true and complete to the best of our knowledge. It is offered without guarantee on the part of the author or The History Press. The author and The History Press disclaim all liability in connection with the use of this book.

This book is dedicated to every player, parent, coach and fan who has made Friday nights in the fall special for so many years. The spirit in the crowd and the energy on the field from the first rep in warmups to the last tackle in the game is what it is all about. None of these emotions and great moments would be possible without all of you!

It is also dedicated to my wife, Emily, and daughters, Maggie and Madelyn. Without your love, support and understanding of Daddy being gone every Friday night—and some Saturdays as well—I couldn't do what I do.
This book is for you!

CONTENTS

ACKNOWLEDGEMENTS

T hank you to my wife, Emily, and my daughters, Maggie and Madelyn. You remain my everything and the reason for breathing. I love you more each and every day, and I'm so proud of all three of you. Without you in my life, I could never do what I do or have the drive to do it. I miss you guys every single minute I spend in the press box, on the sidelines or at the announcer table courtside. It is your love and support that makes it possible and enjoyable! While others may head to bars, parties or other gatherings after games, I cannot wait to race home to you!

Thank you to Coach Chuck Kyle for inspiring me as a little boy to watch high school football and then again as an adult to write about it. Never did I think that one day you would write the foreword for my book. It truly was a dream come true and a "pinch me, I think I may be dreaming" moment when you agreed to do it. You are a legend and a class act. Congrats and enjoy retirement, coach, you have earned it.

Thank you to coaches, players and fellow media members who helped contribute to this book with interviews and numerous quotes. (Unless otherwise noted, all quotes are from phone or in-person interviews I conducted.) Thank you to the fan bases of Avon and Avon Lake, who both put Kee On Sports on the map with your support when we began and ever since. Without the push you gave us, who knows if we would have grown to become as big as we are. It will never be forgotten, and you can expect a hug and a handshake every time you see me. Keep sharing those articles!

I would also like to thank my staff at Kee On Sports, who sacrifice their time with friends and family to cover games. Kee On Sports is not just me, it is a total team effort, and your contributions to it make us what we are.

I want to thank my parents, Don and Maria McKee, and also my wife's parents, Bob and Debbie Lamb. With your willingness to watch the kids, I was able to leave to cover games earlier than I may have been able to at times. Also, you understand why I may not always be there on time or at a family function at all sometimes. This is a passion that doesn't check other people's personal schedules, and you get that.

To the late, great James Friguglietti, who passed in March 2018. While others didn't have time to read a single word, you edited everyone when I started writing HERO more than twelve years ago. One cent of your knowledge was worth more than a million dollars out of your pocket. I'll never forget how much you helped me every step of the way. That in itself is worth far more than any dollar value.

Last but always first, thank you to my lord and savior, Jesus Christ. It is through your work that all light is shed and peace is obtained.

FOREWORD

As years have gone by, I have realized that coaching was not really my career; it was my vocation. By arriving at that understanding, I have come to an enriched state of mind. I never used coaching as a way to "make the career climb" for a better, more lucrative job. My calling has been to help young men learn the value of preparing mentally, physically and spiritually for any challenge they may face in their lifetime. If they learn that mode of preparation during their football experience, they will win more than their share of football games. And more important, they will have a formula for the more difficult challenges ahead. Football is a great teaching tool.

The players, coaches, parents and volunteers who sacrifice time and effort for high school football should be enthusiastically thanked. During the high school years, it is imperative for teenagers to experience a team setting, and football may be the best scenario for this. About 70 percent of youth who are on travel sports as a young child are no longer in a team situation by their junior year of high school. Many sports have a limit of fifteen to twenty-five players on the roster. In that situation, how many juniors can make a team? Eight, ten or twelve players? Football has plenty of room for a greater number of players. What football coach would balk at having eighty to ninety players on their team? The coach and the school board would be and should be thrilled.

There is no debate that football is the number one spectator sport in the United States, and statistics clearly verify that. The athleticism, strategy and drama are interesting to observers of the game. But the ultimate thrill

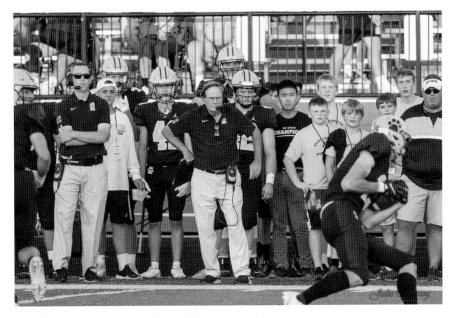

The legend, Chuck Kyle. *Julie Spisak Herzog.*

belongs to the players, who display their athleticism, strategy and drama under the lights for all to see. It takes courage to step forward and play in front of many, risking the chance of failure for the opportunity of success. But fifty years later, the player will recall those intense moments on the field when he looked to the left and he looked to the right and determined to not let his teammates down. In these moments in his life, he was purposely at his best.

—Chuck Kyle

INTRODUCTION

T he game of football lasts a lifetime. Sure, playing ends at different levels for different people, but the memories the game brings last a lot longer. No matter if you're the star quarterback or the backup kicker, a game under the Friday night lights is a moment that brings a sense of unity. In high school, there is nothing like the anticipation of a Friday night football game, bringing the whole community together for one night a week. The tailgating, the student sections and the fall weather (depending on where you live). The big stage. The passion. The true love of the game. There is no feeling quite like a Friday night football game.

Some student athletes play football in high school with kids they went to elementary school with. There's a genuine love for the game, something that sometimes can't be expressed in writing. It's different than college football. Once you hit the collegiate level, things change. The same passion you had for Friday nights changes because of the school you attend. It may not be the school you wanted to go to. And the business aspect often takes over at the college level, and that can supplant feelings you once had in high school. Subtle changes like that can make you lose passion for the game. It's a never-ending cycle.

Covering football is different than doing so for any other sport. Games are played once a week, and the anticipation waiting for Friday to come is unmatched. Football—especially in Northeast Ohio—is rich. Each week presents something exciting. Football on Friday nights creates opportunities most student athletes at the time don't realize will make a lasting impact on

their lives. The bonds built on the football field last a lifetime. Some people realize this at the moment; others take years to come to the realization.

Even as a sports reporter covering games on Friday nights, there's just something in the air that makes it special. It's an honor to be able to attend and write about high school football. There's a story to tell, no matter the school, no matter the fan base, no matter the media outlet, no matter the city.

—Mike Trivisonno, Kee On Sports

1

THE GAME

Massillon vs. Canton McKinley

The schools are located eight miles apart in Stark County, and they simply do not like each other. The two legendary schools began playing football in 1894, and Massillon leads the all-time series, 74-53-5. Everything from books to movies have been produced about the rivalry. When you think high school football rivals, you think Massillon and Canton McKinley.

They have combined for thirty-six Ohio state championships and eleven national championships, and more than fifty players have been drafted into the NFL, thirteen of whom have won Super Bowls. Paul Brown from Massillon and Marion Motley from Canton McKinley are both Hall of Famers from that bunch. But all of these things are facts you can look up in minutes. There is so much more to this legendary rivalry that we are excited to share.

Paul Brown won six straight state titles while coaching the Massillon Tigers in the 1930s. He used that success to propel himself to a job with Ohio State. He then eventually became the first coach and namesake of the Cleveland Browns. Had he not had the success he did at the high school level, perhaps there would have never been a "Cleveland Browns." Think of the magnitude of that.

As I began to sink my teeth into this rivalry—much as a Canton McKinley Bulldog linebacker might sink his teeth into an opposing tailback—I knew there was much more to the story than I could ever tell. So I did what any good writer does: I turned to the experts. I went to fellow media members who have covered the rivalry, players who played in it and historians who I knew would give you, the reader, the full scoop!

I first conferred with legendary Massillon Tiger quarterback and Ohio State Buckeye graduate Justin Zwick. He started his high school career playing for Orrville High School, where he won two state championships. Zwick shared how a trip to Paul Brown Stadium in Massillon led to a major change in his high school journey.

> *I was lucky enough to be a starter at Orrville my freshman year and ended up playing for and winning the Division 4 State Championship that 1998 season. My second year at Orrville, we moved up to Division 3 and again had a very successful year but lost in the State Semi-Finals to the eventual State Champion Poland Team.*
>
> *The game my freshman year was played at Paul Brown Tiger Stadium. I had been to the stadium a few times throughout my childhood and new all about the program. After my sophomore year, I had a good feeling that I was going to be able to play college ball and wanted to test myself by trying my hand at the Division 1 level.*
>
> *Having played in PBTS the year prior—knowing the history of the program and the love the community has for its program, it was a no-brainer. Rick Shepas had just taken over as the head coach—had just had an amazing undefeated year and the quarterback was leaving which I thought gave me a window to go in and compete for that starting job. Making that decision was of course tough for a sixteen-year-old to make but my family and I made the decision to give it a shot, and we never looked back.*

What makes things even more intriguing when it comes to the story of Zwick is the fact that he experienced the mystique of Massillon football long before he ever strapped on a Tiger uniform.

> *I remember going to the 1994 Regional Championship game at the Akron Rubberbowl when I was a kid. I'll never forget the crowd, excitement, toilet paper being thrown for scores and just the amazing atmosphere the game created. Living in Northeast Ohio, you know about that rivalry…to see it firsthand as a youngster in a playoff game with no real rooting interest was my first introduction to how crazy the fan bases are.*
>
> *I will say, I probably had more interest in the McKinley program growing up, only because a teacher of mine who had kids my age was a coach for the Bulldogs and actually took me to a couple games when I was in middle school, but I knew about the rivalry, and it was always a topic of conversation when they played. There wasn't necessarily one thing that*

stood out that intrigued me to want to play in it, I just knew I wanted to test my abilities against the best and I thought going to Massillon would do that.

The senior year for Zwick would go down as the stuff of legend. He thew for 3,821 yards and 40 touchdowns in an amazing season. He reflected on everything that went right to make the magical season happen.

Well, other than all of the great players I was lucky to play with, who kept me clean in the pocket and caught all of those passes, I'd have to say Rick Shepas. He was instrumental in making sure I knew exactly what he wanted the offense to look like and, going into my senior year, put a lot on my plate to make sure I was prepared to have that type of season. He gave me a lot of leeway in calling plays at the line of scrimmage and trusted me to get our offense in the right situation. I was surrounded by a ton of great players/people and was lucky to go out and have a great year.

The 2001 edition of the classic is seen as one of the greatest games in the history of the rivalry. Massillon trailed 26–22 with little time remaining. The Bulldogs had shut out the Tigers the entire second half, and it looked like they were on the verge of pulling off a massive victory. It was then that Zwick and the Tigers put it into full gear with a thrilling last-second drive to win the game in front of 23,815 disappointed and freezing fans at Canton's Fawcett Stadium.

The game-winning drive began at the Tigers' own 28-yard line with 2:52 left on the clock after McKinley was forced to punt for the first time in the second half. A pass from Zwick to Devon Jordan on a cross route for 11 yards got the ball moving, and the drive of the century was underway. From there, it was Ricky Johnson taking a simple draw play that faked out McKinley for an impressive 20 yards across midfield to the McKinley 41-yard line. The Tigers were purring and looking to make history.

From there, Zwick found Robert Oliver on a screen pass that the Tiger took 16 yards to the Bulldog 25-yard line. After a 2-yard loss on first down, Zwick handed off to Oliver on a draw play that went over right guard and broke wide open for Oliver, who bounced off tacklers with the assistance of a massive Joe Jovingo block to score the biggest touchdown in rivalry history.

Down 3, 29–26, with under a minute left, it was a long shot for McKinley to come back and tie the game or even win it, but they came dangerously close. The Bulldogs got inside the 10-yard line, but Massillon senior Craig

McConnell picked off a Palumbo pass to end the game for good as time ran out shortly after.

Zwick recalls that memorable game and the last-second drive. "I remember thinking that was one of the toughest games I had ever been a part of. Was a close game right down to the final seconds when Craig McConnell intercepted a ball to give us the win. No better offensive play call than taking a knee—especially in a rivalry game. McKinley had an awesome team—some really good matchups, and the game really showed how much talent was on the field."

Ironically, following that amazing game, which saw the Tigers improve to 9-1, the two teams saw each other again only a few weeks later in the playoffs. The Tigers won handily, 35–19. They went up 35–7 after three quarters and wisely took Zwick out. He had a two-game stat combination for the ages, completing 40 of 58 passes (69 percent) for 484 yards and 5 touchdowns. He had just 3 interceptions in the pass-happy Tiger attack for both games. He explains why it went so well.

I'll never forget thinking, "Man, we have to play those guys again"—not that I wasn't excited, but that first game was such a tough one and I know how hard it is to beat the same team twice in a year, let alone only having like two weeks in between. Also remember thinking, this is why you come to a place like Massillon—so you test yourself against the best in big games. The playoff game at the Rubberbowl was probably the best game of my career at Massillon.

Everything I called seemed to work, and like you mentioned, we put a pretty good pounding on them till late in the fourth. I remember getting greedy toward the end and trying to thread a needle in the end zone that was intercepted. Shep met me on the sideline with a "This WAS your best game until you made that bonehead throw." But with the game basically out of reach it didn't come back to bite me. We did just about whatever we wanted that game, and it was a totally different feel from the regular-season game.

Having that experience of playing them just a couple weeks before definitely helps prepare—you know how they reacted to certain formations/calls, but you also know they're going to try and change up what they did in the prior game, so you can't put too much into it. They had the opportunity to do the same scouting on us, so we were prepared for new wrinkles, and like I mentioned, everything we did for whatever reason just seemed to work that night.

Justin Zwick would go on to graduate in the spring of 2002 and move on to Ohio State University. His freshman year was every bit as memorable as his high school career. The Buckeyes under Jim Tressel went on to win the national championship. They went 14-0 and defeated the seemingly invincible and highly favored Miami Hurricanes in double overtime in the Fiesta Bowl.

While playing at The Ohio State, Zwick got to compete in another famous rivalry: his Buckeyes and the Michigan Wolverines. Zwick touched on that as well.

> *The fan bases are what make the rivalries so special in my opinion—just on different levels. College has thousands of new fans every year and alumni, so it just gets compounded and is a national deal. Northeast Ohio—in those two cities, that game is always the most important—for OSU/UM it's state versus state, which just amps it up. Once I committed to Ohio State and would get questions about the OSU-UM rivalry, I'd always compare it to the Massillon-McKinley rivalry, just on a different level and say there's no better way to get ready for that rivalry in college than playing in the one I was able to in high school.*

People travel from all over the state, and some from all over the country, to attend this game every year. Zwick was not shy on why he feels that is:

> *Football was born in Northeast Ohio. Those two schools have been going at it for so long, and it's always meant the world to each community. Once you experience it, there is no turning back. I was lucky enough to take my wife back to experience it for herself a few years ago, and she was blown away, just couldn't believe it. From the downtown decorations when you drive through, the pep rally, tailgating, size of the crowd, it just blew her away. I, of course, tried to explain it to her beforehand, but until you see it all in person, it's hard to comprehend.*

My second stop researching this historic rivalry was speaking with Don Engelhardt, Gary Vogt, Mike Riordan and Eric Smith of the Massillon Booster Club. They provided the information that follows and proved to be the utmost experts on the rivalry. In fact, I would encourage everyone to stop by their website (www.massillontigers.com), as I did, to learn everything going on not only with the rivalry but also all things Massillon Tiger football. Make sure to check it out today and support the boosters.

Without any further ado, here is what I learned firsthand from speaking with Eric, Don, Gary and Mike, in their very own words.

No high school football rivalry in the nation can claim the extraordinary tradition of Massillon versus Canton. The rivalry has thrived for over one hundred years. It's bigger than a family feud, and it's more intense than a street fight. In fact, it's almost akin to going to war. And the success or failure of each team is often based on its outcome.

There is a sense of pride and purpose, and the game spills over into every walk of life. The players celebrate each victory and vow to avenge any loss the following year. Such is the intensity of the competitiveness between the Massillon Tigers and the Canton McKinley Bulldogs. There is no love lost between them; the two schools really do hate each other. But they have also earned each other's respect. It takes two great teams to make a great rivalry.

To outsiders, it's difficult to comprehend how mature adults can become so enamored of a simple game played among high school teenagers. Perhaps one has to grow up with it in order for it to really make sense. Or is it simply the thrill of watching local boys being thrown into the fire and emerging at the end of the day as young men? But no apologies are made, and no forgiveness is expected. It's the greatest high school sports happening every year in this hotbed of high school football.

Destiny defines the players who participated in this grand affair, and they carry the outcome with them for the rest of their lives. Their stories are heroic, their deeds memorable. And they will live forever in the hearts of generations to come.

Here is the story of the greatest high school football rivalry in the nation.

Why the Game Is So Big

Massillon and Canton are situated just eight miles apart, both located in Stark County in Northeast Ohio, considered by many to be *the* place for high school football. So it's natural that they would play each other every year, as they have from the early days of the sport to today. There have been 132 meetings. Few Ohio teams can match this duration.

But longevity alone does not make a rivalry great. Many other factors are involved.

The show is big! Crowds of twenty thousand or more. The Tiger Swing Band and the Bulldog Marching Band, with their pregame and halftime shows and musical support throughout the game. The student mascot

wearing a tiger head and skin. The balloon launches when the teams come out. The rabid support provided by the students' "Village Idiots." The fireworks after the scores. The live tiger and bulldog mascots. The all-morning tailgating. The special guests. The sports souvenir shops doing a thriving business during the week of the game. And the players performing at an intensity level far exceeding that found in other matches.

The Start of the Rivalry

Oddly, the Massillon-McKinley rivalry has its roots in commerce, not sports. In the 1800s, the Ohio and Erie Canal, used to transport farm goods and commodities to market, was routed through the center of Massillon. The town became the hub for commercial activity in Stark County. But several years later, the railroad replaced the canals, and due to some deep pockets in Canton, the tracks were laid there. Suddenly, Canton became the hub and eventually the county seat.

The rivalry then moved to sports when each town entered the professional football arena, competing as the Tigers from Massillon (1903–19) and the Bulldogs from Canton (1905–19). Such was the intensity of the competition that in order to gain an edge, Massillon's team "raided" the pro team from Akron for players and signed Notre Dame's head football coach, Knute Rockne.

Financial support for this endeavor was provided by local businessmen. In order to keep pace, Canton loaded their team with out-of-town professionals and signed Jim Thorpe from Carlisle as their star running back. This effort made the two teams tops in the country for several years and created quite a showcase.

From 1903 through 1907, the Tigers compiled a record of 41-1-2 and captured five national championships, with two of the title games coming against the Bulldogs. Canton achieved success a few years later, from 1916 to 1919, winning three national championships with a record of 27-1-2. And the games between the two teams were classics.

But by 1920, Massillon could no longer keep pace economically with the fast-growing sport and disbanded its team. Canton lasted just a couple of years longer. With their departures, the rivalry was now solely owned by the high schools. Thus was born the Massillon-Canton rivalry that we know today.

It was in early November 1894 that the two teams met for the first time, at Canton's Pastime Park. The Canton "Varsity Club" (later the Canton Athletic Club) won that encounter, 16–6, and also won the rematch, 12–8,

at Massillon's Russell Park in front of two hundred fans paying fifteen cents a ticket. Canton would go on to win the next 9 games until Massillon managed a 0–0 tie in 1907. The following 2 games also went Canton's way.

But the Tigers turned the tables in 1908, winning by the score of 12–6. All three touchdowns were scored during the final eight minutes of play, and all were the result of fumble returns. Massillon also stopped the Bulldogs' frantic effort to tie the score, holding them at the 2-yard line as time expired. The Tigers followed that up in 1909 with a pair of wins by scores of 12–6 and 6–2. It was also the first year that Massillon scheduled a full ten-game season.

Canton owned the series up to that point, 13-3-1, but suddenly a rivalry was born.

After a two-year hiatus (1910 and 1911), the series between Massillon and Canton was ready to take off. Starting in 1912, they began to play each year, and they have maintained that relationship until the present day, a span of over one hundred years.

Through 1917, it was Central High School that was on the Canton end of the rivalry. This changed in 1918, when the new Canton McKinley High School opened. But all of the games, regardless of school name, factor into the overall series record.

During the period 1912–31 and prior to the arrival of Massillon's Paul Brown and McKinley's Jimmy Aiken, both teams fashioned some outstanding seasons and played many fierce games against each other.

The Tigers were unbeaten in both 1916 and 1922, defeating the Bulldogs by scores of 16–9 and 24–0. One-loss seasons were posted in 1915 and 1924, with the 1915 loss coming at the hands of Canton, which returned a fumble 88 yards for a touchdown and converted the extra point. Meanwhile, the Bulldogs recorded one-loss seasons in 1920, 1926 and 1927, beating Massillon in two of the three years.

Massillon coaches John Snavely (1914–19) and Dave Stewart (1921–25) were each 4-1 versus the Bulldogs.

Two of the more famous players to emerge from the rivalry at that time were Massillon's Harry Struhldreher and Canton's Edgar "Rip" Miller, who was the captain of the 1920 Bulldog team. After high school, both ended up playing for Knute Rockne's 1924 national championship team at Notre Dame. Struhldreher was the quarterback and a member of the legendary "Four Horsemen," while Miller was one of the "Seven Mules."

With Massillon holding an 11-6-2 edge during that era and the overall series standing 19-14-3 in favor of Canton, the stage was now set for some of the biggest Massillon-McKinley games.

THE PAUL BROWN YEARS (1932–40)

With the Massillon and Canton McKinley programs on the verge of success yet suffering through dismal seasons in 1931, both hired new coaches in order to regroup their football fortunes. For McKinley, it was Jimmy Aiken, who would coach four years and compile a fine 32-7-0 record. Later, he would become head coach of the University of Akron (19-7-1), the University of Nevada (38-26-4) and the University of Oregon (21-20). But more important for Canton, Aiken beat the Tigers three times out of four tries.

Aiken was followed by Johnny Reed, who lost just 7 games in his five-year career in Canton and posted four one-loss seasons. But five of those seven losses were to Massillon's coach, Paul Brown.

Massillon hired the twenty-four-year-old Brown out of Severn Prep, Maryland. Brown stayed in Massillon for nine years and compiled a record of 80-8-2, capturing six state titles. He also coached in 9 Massillon-McKinley games, second only to Mike Currence. But his tenure there got off to a rocky start when he dropped his first 3 games to McKinley and was outscored, 61–6. Adding misery to the story, his 1934 team entered the game unbeaten and unscored upon, only to see Canton, which was also unbeaten, dominate with a 21–6 victory and capture both the state and national championships.

Those three losses almost cost Brown his job. In fact, it nearly ended the series with Canton when powers-that-be in Massillon suggested it was enough. Fortunately, both schools met in the following off-season and agreed to continue.

Brown turned his fortunes around the next year by beating McKinley, 6–0, behind star running back Bob Glass, who scored the lone touchdown on fourth down at the 3-yard line. Brown's team finished the season 10-0, and he captured his first state title. By the time he left, he had compiled a streak of six consecutive victories over the Bulldogs, with a scoring margin of 112–18. His final game was played in 1940, with both teams entering the fray unbeaten. McKinley scored first, recording the only points surrendered by the Tigers that year. But Massillon tallied the next 34 and ran away with the victory. Brown left the following year to become head coach at Ohio State University (18-8-1).

THE DOMINANCE SWINGS WEST (1941–71)

Paul Brown laid the foundation for successful Massillon football, and after his departure, the Tigers went on a tear, dominating the Massillon-Canton series for the next thirty-one years. The Tigers' record during that time was 21-8-2, and they outscored McKinley, 610–331. Included in that run was a 7-game winning streak (1948–54) and a 9-game winning streak (1957–65). Massillon also captured fifteen state titles and five national titles.

In addition, the all-time series record between the two teams swung in favor of the Tigers. All of this could not have happened without the leadership of several outstanding coaches, including Bud Houghton, Chuck Mather, Tom Harp, Lee Tressel, Leo Strang, Earle Bruce and Bob Commings. They all went on to become head coaches in college. The contests were also characterized by huge crowds, which averaged nearly 22,000 per game.

The year 1970 brought perhaps Massillon's greatest team since Paul Brown's tenure. Led by future Iowa University coach Bob Commings, the Tigers compiled a record of 10-0, outscoring the opposition, 412–29, and capturing Massillon's last AP Poll State Title. In the final game of the season, Massillon defeated previously unbeaten Canton McKinley, 28–0.

Meanwhile, the Bulldogs had great seasons in 1955 and 1956, both times winning the big game and capturing the state title. Some of their better coaches were Bup Rearick, Ron Chismar and Don Nehlen.

There were many outstanding head coaches during this period. But one assistant coach really made his mark. Carl "Ducky" Schroeder, who played fullback for the Tigers in 1923 under Coach Dave Stewart, was hired by Chuck Mather in 1948 to coach the offensive line. He would stay in Massillon for twenty-three years. During his span, Schroeder was instrumental in helping the Tigers to an 18-5 record over the Bulldogs. He was also a part of thirteen state and five national championships. Today, the Carl "Ducky" Schroeder Outstanding Offensive Lineman Award goes annually to a deserving Massillon player.

ON TO PRESENT DAY (1972–2021)

Many times, the winner of the Massillon-McKinley game was voted the state champion by the Associated Press or had a marked influence on who was eventually crowned. But the year 1972 signaled the introduction of a postseason playoff to determine the state champion. However, this sudden

change did not diminish the significance of winning in the great rivalry. And many fans will tell you that achieving victory in the finale was more important than qualifying for the playoffs, citing the large crowds, media attention and bragging rights that overshadowed that of any playoff game. No one asks a former player what their playoff record was. But they will ask how you fared in the Massillon-McKinley game.

From 1972 to 2019, the series between the two teams has been played on a more even level, with Massillon winning 32 games and McKinley winning 23. In this period, the Tigers scored 1,003 points and the Bulldogs 949. More than half of those games were decided by a touchdown or less.

Both teams maintained superiority over much of the competition. Massillon qualified for the first-ever playoffs and would go on to capture twelve regional playoff championships. Four times they advanced to the state finals but lost each time. McKinley grabbed nine regional champions and made it to the finals six times, winning three.

The one hundredth game in the series was held in 1994. So important was the interest that both ESPN and *Sports Illustrated* covered it, and former Green Bay Packer quarterback and Pro Football Hall of Fame inductee Bart Starr tossed the coin before the kickoff. And the game did not disappoint, becoming one of the most exciting high school contests ever played. The game was tied at 35 at the end of regulation, and the Tigers won dramatically in overtime, 42–41, in front of a capacity Paul Brown Tiger Stadium crowd of 19,125. The two teams combined for over 700 yards of offense, and neither led by more than a touchdown throughout. But a missed extra point in overtime became the difference. McKinley would get its revenge in the playoffs two weeks later, winning, 27–20.

In 2015, Canton's Fawcett Stadium was replaced with Tom Benson Stadium. By the time of the last game played at Fawcett Stadium, the visitors' stands had been demolished; all of the fans were situated on the home side of the stadium. By 2017, Benson was nearly completed, and the game went on as normal.

Student enrollments in the two schools peaked around 1972, but this period also saw the start of a gradual decline in both enrollment and football roster size. Today, Massillon's enrollment has been reduced by about a third, and as a result, the school has dropped a level in playoff assignment, from Division 1 to Division 2. McKinley, on the other hand, was able to keep pace with the numbers for a while when the Canton City Schools closed two of its four high schools in 1976 and then consolidated to a single high school in 2015.

Today, McKinley maintains its status as one of the largest schools in the state. Regardless, achieving success in the playoffs today has become much more difficult, owing to the domination of the parochial schools, which started coincidental with the playoffs. Five regional championships have been captured by Massillon in the past ten years, in 2009 by Massillon in Division 1 and in 2017, 2018, 2019 and 2020 by Massillon in Division 2. None by Division 1 McKinley.

THE UNDEFEATEDS

Every Massillon-McKinley game at the time it's played seems like the biggest game ever, such is the intensity of the rivalry. Some teams wrapped up undefeated seasons and either claimed or were awarded state titles. Others advanced to the state playoffs on winning notes with the anticipation of success to come. Still, several teams salvaged their seasons by knocking off previously unbeaten opponents or winning in spite of being decided underdogs. But certain games were indeed considered the biggest of them all, especially when both schools entered the fray unbeaten. Here is a rundown of those games.

1934 – Massillon was unscored on, and McKinley had surrendered just two touchdowns. The game drew 20,000 fans (the stadium was enlarged from 10,000 to 22,000 for the game), setting an all-time attendance record for the state of Ohio. Canton won, 21–6, and laid claim to both the state and national championships.

1936 – Massillon beat Canton, 31–0, and subsequently claimed the state championship. McKinley's Johnny Reed suffered his first loss as a coach in 45 games.

1938 – Déjà vu. Massillon won, 12–0, and captured its fourth consecutive state title.

1940 – Paul Brown won his final game as a Tiger coach over McKinley, 34–6, winning his sixth consecutive state title. His next stop was Ohio State.

1942 – Canton upset Massillon, 35–0, snapping the Tigers' 52-game unbeaten streak.

1943 – The Tigers got revenge, winning, 21–0.

1955 – McKinley captured the state title with a 13–7 victory over 8-0-1 Massillon.

1964 – Entering the game, Massillon was first in the state with a 9-0 record and was led by future Ohio State head coach Earle Bruce. McKinley was second in the state with a 9-0 record and was headed by future West Virginia head coach Don Nehlen. McKinley took a 14–0 lead into the fourth quarter, only to lose, 20–14. Massillon finished first in the state and second in the nation.

1970 – Massillon, first in the state, won convincingly, 28–0, over 8-0-1 Canton McKinley (third in the state). The Tigers would maintain its ranking following the game and finish second in the nation.

2005 – Massillon's bid for an undefeated season was foiled, 38–8. But the Tigers would turn the tables three weeks later, winning, 21–3, and later advancing to the playoff state championship game.

SNATCHING VICTORY FROM CERTAIN DEFEAT

The Massillon-McKinley rivalry has brought some of the most exciting games to high school football. Nothing can be as memorable as watching a last-minute score that propels a team to victory. Here are the top six comebacks in Massillon-McKinley history.

1964 – Both teams entered the contest with 9-0 records, with Massillon ranked first in the state and McKinley second. The Bulldogs had opened up a 14–0 halftime lead and held that into the fourth quarter. With Tiger quarterback Steve Kanner out with leg cramps late in the game, junior Dave Sheegog came in and engineered one of the greatest comebacks in Massillon history. The first score came at the 10:11 mark of the fourth quarter, when Jim Lawrence went over from the 1-yard line to cap a 40-yard drive, making the score 14–6. After regaining possession at their own 39, the Tigers again drove to the end zone, with Bob Hewitt going in from the 1. Sheegog then scored the 2 extra points to tie the game at 14 with 3:32 left.

The Bulldogs failed to move, and Sheegog returned the punt 33 yards to the McKinley 17. On third and 7, Sheegog faked the handoff and sped

toward the end zone, eluding several tacklers along the way. He crossed the goal line with fifty-four seconds left. The score gave the Tigers a 20–14 win and the eventual state title.

1974 – Canton McKinley was unbeaten and headed toward a certain bid in the playoffs, whereas Massillon was struggling through a 5-4 season. But the Tigers would have none of that underdog talk. They opened a 14–0 halftime advantage. McKinley flexed its muscles in the second half with two touchdowns and a 25-yard Roch Hontas field goal to assume a 15–14 lead with just seventy-three seconds left. There was little time left to turn the tables. But Massillon did just that.

Three down-and-out passes from Greg Wood to Eddie Bell, minus a quarterback sack, advanced the ball to the McKinley 33 with just thirteen seconds left. Somehow on the next play Wood avoided the blitz, stepped to his side and unloaded a long pass to Eddie Bell, who beat his defender and caught the ball in the end zone for the game-winner. For Tiger fans, pandemonium ensued. But for the Bulldogs, the loss eliminated them from playoff contention. (Only one team from each region qualified in the early years of the tournament.) It was New Philadelphia that took their place.

1978 – Massillon was unbeaten entering the annual fray and needed a win over McKinley to keep the streak alive and capture first place in the All-American Conference. The Bulldogs, however, had other plans and dominated play throughout most of the game, leading 10–0 deep into the fourth quarter. But that's when Massillon quarterback Brent Offenbecher went to work, completing 9 of 9 passes in the final frame. Rolling to either his left or right in the run-and-shoot offense, he effectively utilized his wide receivers to move the ball down the field, alternating between down-and-outs and inside slants. The two needed scores eventually came from receptions by Curt Strawder, the latter score having been set up by a Tim Reese interception.

2001 – In a back-and-forth, highly charged contest, Canton McKinley (7-1) entered the fourth quarter with a 26–22 lead over Massillon (8-1), which was led by OSU-bound Justin Zwick. But a 27-yard run by Robert Oliver, the Tigers' only score of the second half, gave Massillon the lead for good with just a couple of minutes remaining. However, with the game still in the balance, McKinley drove to the Tiger 18-yard line and on third down heaved the ball toward the end zone. But Massillon's Craig McConnell stepped in front of the Bulldogs' Reggie Conner at the last moment to intercept the pass and preserve the win for his team.

2011 – One of the most exciting finishes in the Massillon-McKinley rivalry came in game number 122. Four touchdowns were scored in the fourth quarter, two by each team. With just 1:13 remaining and Massillon trailing, 16–14, Alex Winters rambled 43 yards to give the Tigers a 20–16 lead. But the Bulldogs came right back and drove 74 yards to the end zone, aided by the accurate passing of quarterback Tyler Foster, who completed all 3 of his passes for 65 yards. Foster then scored the winning points, going over from the 3-yard line with just nine seconds remaining.

2015 – The teams traded scores for three and a half quarters, and McKinley was clinging to a 24–21 lead, deep in its own territory. On third and 5 from its own 30, Bulldog quarterback Dominique Robinson, under great pressure, threw a desperation pass that was intercepted by Massillon's Dakota Dunwiddie, who returned it for a score. The point after gave the Tigers a 28–24 lead with 3:14 left in the game. One more defensive stop, and it would be Massillon's win. But Robinson, having a career day with his running and passing, led his team to victory, scoring the winning points with just twenty seconds left. It was a twelve-play, 69-yard drive in which Robinson completed 4 of 7 passes for 47 yards, including a fourth-down conversion. He also ran 1 yard for the winning score.

NOTABLE COACHES IN THE GAME

Several coaches from both Massillon and McKinley had stellar careers that started locally and propelled them to collegiate and professional head coaching positions. Two of these coaches provided perhaps the most intriguing matchup in the series when, in 1964, Earle Bruce of Massillon faced off against Don Nehlen of Canton McKinley. Massillon won that day, 20–14. These two coaches would meet again in 1987, when Bruce's Ohio State team defeated Nehlen's West Virginia team, 24–3.

Massillon
Paul Brown (1932–40) (Ohio State, Cleveland Browns, Cincinnati Bengals)
Bud Houghton (1941, 1946–47) (Akron)
Chuck Mather (1948–53) (Kansas, scout for Chicago Bears)
Tom Harp (1954–55) (Cornell, Indiana State)
Lee Tressel (1956–57) (Baldwin Wallace)

Leo Strang (1958–63) (Kent State)
Earle Bruce (1964–65) (Tampa, Iowa State, Ohio State)
Bob Seaman (1966–68) (Wichita State)
Bob Commings (1969–73) (Iowa)
Lee Owens (1988–91) (Akron, Ashland)
Rick Shepas (1998–2004) (Waynesburg)

Canton McKinley
Jimmy Aiken (1932–35) (Akron, Nevada, Oregon)
Ben Schwartzwalter (1941) (Muhlenberg, Syracuse)
Don Nehlen (1964) (West Virginia)
Ron Chismar (1965–69) (Wichita State)

Thom McDaniels holds the record for the most wins in the series with 11. He also coached in the most games (18). The other coaches with the most wins are as follows:

Massillon
Mike Currence 7-3 (1976–84)
Chuck Mather 6-0 (1948–53)
Leo Strang 6-0 (1958–63)
Paul Brown 6-3 (1932–40)
Jason Hall 6-3 (2008–14)

Canton McKinley
Thom McDaniels 11-7 (1982–97, 2014)

The Record Setters
Throughout the history of the Massillon-McKinley rivalry, nearly every game has been decided by outstanding team effort. But occasionally, an individual's play stood out that, as far as fans were concerned, was deemed to be the deciding factor in the outcome. What follows are many but not all of those players.

Massillon Quarterbacks
Justin Zwick (2001) – Two games were played in 2001, including one in the second round of the playoffs. Both were won by the Tigers, by scores of 29–26 and 35–19. Combined, Zwick completed 40 of 58 passes (69 percent)

for 484 yards and 5 touchdowns, with just 3 interceptions. In the playoff game, Justin led his team to a 35–7 lead by the end of the third quarter and coasted home for the win. He later played for Ohio State.

Kyle Kempt (2012) – Two games were played in 2012, including one in the second round of the playoffs. Both were won by the Tigers, by scores of 37–29 and 28–19. Combined, Kempt completed 27 of 49 passes (55 percent) for 462 yards and five touchdowns, with just 1 interception. Kyle's 52-yard TD pass to Gareon Conley with two minutes left in the first half of the playoff game gave Massillon an insurmountable lead. He later played for Oregon State and Iowa State.

Aidan Longwell (2017–19) – Longwell was the starting quarterback for three consecutive years and led the Tigers to victory in each one, with scores of 16–15, 24–17 and 24–14. Combined, he connected on 32 of 51 passes (63 percent) for 357 yards and 3 touchdowns. Longwell ended his Massillon career as the all-time leader in passing yards, touchdowns and completions.

Willie Spencer Jr. (1994) – It was in the one hundredth game of the rivalry that Spencer showcased his athletic abilities, running and passing to lead the Tigers to a 42–41 overtime victory. Willie completed 6 of 13 passes for 103 yards and 2 touchdowns while running for another 94 yards and 1 touchdown on 12 carries. The two biggest plays were a 62-yard flea-flicker TD to Victor Redrick and a timely quarterback option pitch to Redrick for the winning touchdown in overtime. Spencer later played quarterback for Akron and wide receiver for Tiffin and the Chicago Bears.

Bobby Huth (2005) – The Tigers lost the regular-season encounter with Canton McKinley, spoiling a quest for an undefeated record. But a rematch during the playoffs went Massillon's way, as Huth led his team to a 21–3 victory. In the latter, he completed 9 of 11 passes (82 percent) for 121 yards and 1 touchdown, with just 1 interception. Huth would eventually quarterback his team in the playoff state finals, where Massillon lost by a touchdown to Cincinnati St. Xavier.

Brent Offenbecher (1978) – Entering the contest 8-0-1, Massillon needed a win over Canton McKinley to secure an undefeated season. But the situation was dire, with the Bulldogs holding to a 10–0 lead midway through the fourth quarter. That's when Offenbecher went to work, connecting on

all 9 passes for 2 touchdowns and a 13–10 victory. For the game, Brent completed 17 of 20 passes (85 percent) for 176 yards and 2 touchdowns, with no interceptions. The previous year he had led the Tigers to a 21–0 upset over the unbeaten Bulldogs with a 7-of-9, 2-touchdown passing effort. Offenbecher would later play for Wake Forest and Ohio State.

Travis McGuire (1991) – It was arguably the most amazing performance by a participant in this long rivalry. Carrying the entire offense on his shoulders, McGuire rushed for a game- and Massillon-record 302 yards in 36 carries and scored 5 touchdowns to lead his team to a 42–13 victory and a spot in the state playoffs. For the year, Travis gained 1,976 yards in 13 games and scored 164 points. "You always think about having that big game against McKinley growing up, playing in the yard," said McGuire. "You know, as a kid you pretend the game's on the line, you're on the 2-yard line, you're Chris Spielman, something like that. But to rush for 300 yards in front of that many people, and score 5 touchdowns. To gain 300 yards in the biggest game of your life, it's kind of overwhelming."

Jamir Thomas (2018) – Assuring his team of an undefeated season, Thomas rushed 35 times for 269 yards and scored 2 touchdowns in a 24–17 win. Asked about the effort, Jamir said, "Because this is the last Massillon-McKinley game I ever get to be a part of. It's just unbelievable. I love my team." Jamir started four years for the Tigers, three as running back, and set career records for rushing attempts, rushing yards, rushing touchdowns, all-purpose yards and total points scored. He also tied the record for total touchdowns scored.

Homer Floyd (1954) – In front of a packed house at Tiger Stadium, Floyd rushed 28 times for 263 yards, which stands as the third best all-time for Massillon. He also scored 2 touchdowns in leading his team to a 26-6 victory and a seventh straight triumph over the Bulldogs. When asked after the game how he felt, Homer said, "Fine. The boys sure blocked swell for me today. I couldn't have run without them." Floyd later played for Kansas and then professionally for the Edmonton Eskimos.

Ryne Moore (2012) – A second-round playoff game at Kent State University against the Bulldogs went the Tigers' way by the score of 28–19. Not to be overshadowed by the passing of quarterback Kyle Kempt, Moore partially stole the show with a career performance, rushing 27 times for 227 yards and 2 touchdowns, including a long run of 62 yards. In this one, Ryne

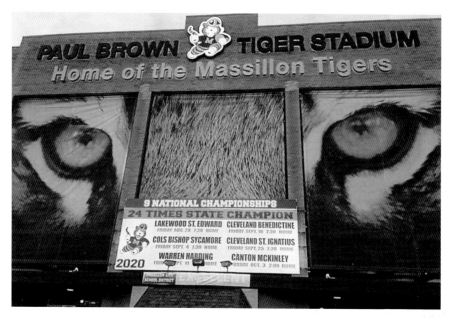

Another shot of Paul Brown Stadium. *Author photo.*

Massillon Tigers training complex, which keeps athletes ready all year long. *Author photo.*

had an uncanny ability, depending on the initial response of McKinley's opposing linebacker, to either run inside the tackle or cut outside in order to gain the maximum yardage. Moore later played for Walsh College.

Art Hastings (1960) – Playing an all-around game against the Bulldogs, Hastings was an unstoppable force, rushing 14 times for 213 yards and scoring 4 touchdowns on runs of 15, 29, 51 and 5 yards. His effort helped Massillon defeat McKinley, 42–0. During his high school career, Art rushed for over 2,400 yards and scored 220 points.

J.T. Turner (2008) – If ever there was a player who completely took over this rivalry game, it was J.T. Turner. On offense, he rushed 28 times for 208 yards and scored 1 touchdown. On defense, he recorded 6.5 tackles and forced a fumble. But he ultimately led by example throughout the game, and the players followed with a similar effort in defeating McKinley, 17–0.

MASSILLON WIDE RECEIVERS

Devin Jordan (2001) – Justin Zwick–to–Devin Jordan was a special combination, and it was showcased at the highest level during the regular-season matchup. Jordan hauled in 10 passes for 154 yards, including a 36-yard touchdown, in helping his team to a 29–26 victory. Devin later played for Ohio State and currently coaches in college.

Bruce Spicer (1984) – In a losing effort, Spicer was one of the bright spots, catching 11 Mike Scott passes for 104 yards. During the season, Bruce led the team with 54 catches for 583 yards and returned 4 punts. He was also named All-Ohio.

Rameir Martin (1989) – Martin was the favorite target of quarterback Lee Hurst throughout the season, and this continued against Canton McKinley. In this one, Rameir caught 9 passes for 110 yards and 1 touchdown. His 21-yard leaping TD catch opened up a 21–7 second-quarter lead for the Tigers and essentially put the game away, the final score being 24–7. Martin later played for Bowling Green.

Curt Strawder (1978) – During a 13–10 comeback victory, Strawder caught 8 passes for 91 yards and 2 touchdowns. For the season, he recorded 42 passes for 553 yards and 4 touchdowns. Curt later played for Wake Forest.

Jayden Ballard (2019) – Ballard caught 9 passes for 114 yards and 2 touchdowns in helping the Tigers to a 24–14 victory over Canton McKinley. His third-down, 79-yard grab from quarterback Aidan Longwell with 1:18 remaining in the game sealed the win for the Tigers.

Massillon Special Teams

Larry Harper (1970) – A wingback on Massillon's state championship team, Harper returned the opening kickoff 94 yards for a touchdown in a driving rainstorm. The score propelled Massillon to a 28–0 victory over previously undefeated Canton McKinley and number one in the final state rankings.

Mark McDew (1967) – After the Tigers took a 14–7 third-quarter lead following a safety, McDew returned the ensuing kickoff 91 yards for a touchdown. Massillon eventually held on for a 20–15 victory and a second-place finish in the final state poll.

Keyshawn Watson and Deonne Harper (2015) – Both players returned record kicks for touchdowns in the same game. Watson returned the opening kickoff 96 yards, and Harper took back a kickoff 89 yards to give the Tigers a 21–18 third-quarter lead. However, McKinley eventually captured the victory.

Canton McKinley Quarterbacks

Dominique Robinson (2015) – A quarterback, Robinson had a career day against Massillon, rushing 18 times for 50 yards and 2 touchdowns and completing 20 of 42 passes for 272 yards and a pair of TDs. He also scored the winning touchdown on a 1-yard rush with just twenty seconds left in the game to give the Bulldogs a 30–28 victory.

Tyler Foster (2011) – Foster quarterbacked the Bulldogs to a 23–20 win using his arm and his legs. On the ground, he rushed 26 times for 34 yards and 1 touchdown. In the air, he was 13 of 20 for 144 yards and a pair of TDs. He also scored the winning touchdown with just nine seconds left.

Eric Glover-Williams (2012) – Glover-Williams was a thorn in the side of the Tigers every time he touched the ball. But he was never able to beat

them. In spite of that, he posted some very good numbers in the 2 games he played in 2012. Combined, he completed 29 of 57 passes for 387 yards and 4 touchdowns. He also rushed 47 times for 174 yards and 2 touchdowns.

Kyle Ohradzansky (2009) – Ohradzansky connected on 8 of 11 passes for 133 yards and 2 touchdowns to give the Bulldogs a 35–21 victory over Massillon.

Nap Barbosa (1955) – Barbosa ran for 61 yards and scored a touchdown in leading his team to a 13–7 victory over previously undefeated Massillon. McKinley finished 10-0, winning the state title.

Canton McKinley Running Backs

Morgan Williams (2005–06) – In 2005, Williams rushed 39 times for 239 yards and scored 4 touchdowns in a 38–8 regular-season victory. Williams returned in 2006 to rush 29 times for 160 yards in a 10–7 loss.

Adrian Brown (1995) – Brown gained 229 of his team's 244 yards rushing and scored all 3 touchdowns in a 24–21 win.

Michael Doss (1998) – Doss rushed 14 times for 155 yards and scored 4 touchdowns in leading his team to a 42–20 victory. McKinley went on to capture the playoff state title.

Jeff Richardson (1986) – Richardson rushed 19 times for 141 yards and scored 2 touchdowns in a 23–6 win.

DeMario Rozier (1997) – Rozier rushed 23 times for 141 yards and 2 touchdowns. The Bulldogs won, 27–14, and later won the playoff state title.

Kinta Mitchell (1994) – Mitchell scored 4 touchdowns in a 42–41 loss during the one hundredth game.

Marion Motley (1936–38) – Motley was one of the most prolific running backs in Canton McKinley history, averaging 17 yards per carry his senior year. He lost only 3 games in high school, all to Paul Brown's Massillon teams. Brown later signed Motley to play for the Cleveland Browns.

Canton McKinley Wide Receivers
Shaquille Perry (2015) – Perry caught 7 passes for 117 yards in a 30–28 victory.

Jeff Richardson (2012) – During 2 games that year, Richardson caught 7 passes for 161 yards and scored a touchdown. Both efforts came in losses.

Canton McKinley Defense
George Tabron (2006) – Tabron recorded 11 solo tackles, 5 assists and 2.5 tackles for loss in a 10–7 defeat. The total tackle points (13.5) was the highest mark for either team since defensive records were kept.

Reggie Young (2017) – Young had 9 solo tackles, 2 tackles for loss and 1 sack. But his team lost, 16–15.

Doak Walker (2014) – Walker had 8 solo tackles, 5 assists and 3 tackles for loss in a losing effort, 31–12.

James Smith (2013) – Smith recorded 9 solo tackles and 4 assists in a 34–7 loss.

Jalen DiCenzi (2012) – In a playoff game at Kent State, DiCenzi had 8 solo tackles, 7 assists, 5 tackles for loss and 3.5 sacks during a 28–19 loss.

The Victory Bell

The "Victory Bell" is awarded annually to the winner of the Massillon-McKinley regular-season game. It was originally a component of Locomotive Engine No. 922, which was owned by the Wheeling and Lake Erie District of the Nickel Plate Railroad. In 1957, after two million miles of service, the engine was retired and the bell donated to Massillon and McKinley as a trophy going to the winner of the annual rivalry game. Massillon won that first contest, 25–7, and kept the bell for nine consecutive years before the Bulldogs finally had a chance to see it in 1966.

GAME CROWDS

The Massillon-McKinley game annually draws near-capacity crowds, something that few other high schools can match. Being the last regular-season game and contested on a Saturday afternoon, the fan interest leading up to and during the game can be compared on a smaller scale to the Ohio State–Michigan game. Earle Bruce, who coached at both Massillon and Ohio State, summed it up best when he said that there was more pressure to win at Massillon than at OSU.

The game experienced large crowds as early as 1922, when 6,000 fans packed Massillon's Jones Field. But by the mid-1930s, it became apparent that the smaller Massillon and McKinley venues were inadequate to support the game. So, as part of President Franklin Roosevelt's Works Progress Administration (WPA), Massillon constructed the 14,500-seat Tiger Stadium, which opened in 1938, and Canton built the 15,000-seat Fawcett Stadium, which opened the following year.

Immediately, both were filled to capacity when the big games were held. Through later renovations, the capacity of Tiger Stadium was increased to 22,000 using temporary end zone and track seating, and the capacity of Fawcett Stadium was increased to 23,000. Today, Tiger Stadium has been reduced to 16,884 owing to smaller, permanent end zone capacity and the elimination of track seats. Fawcett Stadium was replaced in 2015 with Tom Benson Stadium. It has a capacity of about 23,000.

But the largest crowd to witness a Massillon-McKinley game wasn't at either stadium. It was at the Akron Rubber Bowl in 1994, when a playoff rematch drew 29,110 patrons.

At present, an estimated 1.6 million fans have attended the rivalry game.

SIDESHOWS

As big as the game is, it was not unusual for quirky events to overshadow it. Here are a few examples.

Stolen Flag – At the end of Paul Brown's coaching tenure in Massillon, an avid fan constructed a fifteen-by-eight-and-a-half-foot appliqué flag to celebrate Brown's achievements. On the flag was stitched a running tiger and the years in which Brown won state championships, later adding the same award by Bud Houghton. The last time the flag was seen was in

1942, when it flew from a flagpole during the Massillon-McKinley game, the day the Bulldogs snapped Massillon's 52-game winning streak. Dr. David Leffler, a student at the time, informed police that after the flag was removed from the pole, it was ripped from his arms by a "Canton fan." When the thievery went public, the deviant panicked and moved the flag to Youngstown, where it was eventually hung on the wall of a local lawyer's office. It took a long time to locate the flag, but in 1987, its whereabouts were finally discovered, and the flag was then promptly returned without penalty. Following refurbishment, it will hang proudly in the athletic wing at the high school.

Two Games in 1963 – Not since 1909 did the two teams face each other twice in the same season. It was not planned that way, but Canton McKinley's 1962 season had been canceled due to the Ohio high school association's allegation of illegal recruiting. So, in order to recover lost revenue, the teams scheduled two games the following year. Massillon won both by scores of 24–20 and 22–6. Later they would meet twice six times as dictated by the state playoffs.

The Snow Game – Fans of the game woke up on that Saturday in 1977 to a winter storm that dumped seven inches of snow throughout the area. Most wondered if the game would be played. But with a concerted effort by both schools, the Fawcett Stadium grass was cleared and the game proceeded as scheduled. Fans were left to remove snow and ice from their seats and then braved the twenty-degree temperature. The Tigers won that day, 21–0, knocking the Bulldogs from the ranks of the unbeaten. McKinley did, however, advance to the playoff state finals.

Double Seats – Prior to the 1934 contest in which both teams entered the fray unbeaten, some ambitious entrepreneur printed and sold a duplicate set of tickets. Surprised fans overwhelmed the stadium and ended up alternating sitting and standing throughout the game. No culprits were found.

Las Vegas Gets Involved – It was not unusual in the 1970s and 1980s to see Massillon versus Canton McKinley listed with the college schedule on their betting sheets for the week.

Thank you again to the Massillon Booster Club for all of that outstanding knowledge and history.

Everyone has different memories of this rivalry, and I decided to reach out to media members, coaches and players to get their thoughts on why this is so special.

We start our trip down memory lane with WHBC Radio personality Kenny Roda. The "Roadman" spent over twenty years in the Cleveland market at WKNR 850 before arriving in Canton in November 2014. Roda is no stranger to great football, having grown up in Pittsburgh and covering the Browns rivalry with them for now nearly thirty years. He has seen both sides of it and was the perfect person to talk to about great rivalries.

Enjoy the following passage from Kenny Roda.

I knew of the rivalry and the great players that had played in it, but I did not understand the intensity and passion with the rivalry until I was covering it up close and talking with players, coaches and fans from both sides. After experiencing it firsthand on the sidelines and talking with the head coaches all week, in my opinion, it is by the far the greatest high school football rivalry in Ohio and maybe the country. It's treated like the Ohio State–Michigan rivalry, and to a lot of people means more!

I think back to my conversations with former McKinley Bulldogs defensive back Mike Doss and defensive end Kenny Peterson and former Massillon Tigers quarterback Justin Zwick. The intensity and passion when they speak about playing in "The Game" is remarkable. They can remember specific plays and the feeling they had from fifteen to twenty-five years ago on winning or losing against their archrival and they rank it up there, as far as how meaningful a game it is, with any game they've ever played in regardless of the level of competition!

What I believe makes a good high school football rivalry is the passion shown by the players, coaches, alumni and fans first and foremost. This is great because the two high schools being only eight miles apart from each other. The passion, the proximity of the two schools, the combination of hatred and respect, the past legends of the game and the importance of winning "The Game" for bragging rights year-to-year and for the rest of their lives makes it can't-miss!

Then the history of the game with all the greats that have coached in it like a Paul Brown, Earle Bruce, Lee Tressel and Thom McDaniels. Former Ohio State head coach Jim Tressel was a Tigers ball boy for his dad, Lee, in the '50s. Current Las Vegas Raiders head coach Josh McDaniels was a Bulldogs ball boy for his dad, Thom, and would later play quarterback in the game for McKinley.

Other great players that people still talk about are Chris Spielman, Mike Doss, Kenny Peterson, to name a few who went on and had great college and NFL careers.

The first game I really covered was the 126th meeting in 2015 at then Fawcett stadium. It was the final game to be played there before they tore it down and would build what is now known as Tom Benson Hall of Fame Stadium.

Both head coaches, Dan Reardon for McKinley and Nate Moore for Massillon, were in their first year at the respective schools. The game was a heavyweight battle that had so many twists and turns, and it came down to the last four minutes, where both schools made huge plays that seemed to give their team the win. But in the end it was the Bulldogs, with quarterback Dominique Robinson diving and going airborne like John Elway in the Super Bowl and crossing the goal line for the game-winning touchdown and a 30–28 victory.

The town of Massillon is all about Tigers football. Their high school team means more to them than Ohio State versus Michigan, Steelers versus Browns or any other football game or league, college or professional. Their passion is second to none. Hell, they rent out tailgating spots for all Tigers home games and they tailgate like Buckeyes and Browns fans! That's crazy for a high school football team fan base!

Vintage Massillon Tiger helmet. *Author photo.*

Legendary Paul Brown Stadium. *Author photo.*

In regards to my on-air partner and close friend Jeff "J.T." Turk, he's a Bulldog through and through, but he can also be objective when he has to. It's been one-sided as of late in favor of Massillon, and I know that's driving him crazy!

But to be able to get a perspective year in and year out from someone who played in the game and from his friends from both McKinely and Massillon who played in the game is priceless and makes for great conversations, debates and fun every year!

If you've never been to a Massillon versus McKinley game and you call yourself a football fan, you owe it to yourself to attend an upcoming contest, especially at Paul Brown Tiger Stadium in Massillon so you can appreciate the passion the fans, players and coaches have for the greatest high school football rivalry in the country!

THE HOLY WAR

St. Ignatius vs. St. Edward

The greatest rivalry in Ohio high school football resides in Cleveland. It is the "Holy War" between St. Edward and St. Ignatius, and it entails everything good about Ohio high school football. We know that Moeller versus Elder and Massillon versus McKinley are big. There is no denying that. But the Cleveland Holy War is perhaps the biggest of the bunch in my book. And this is my book.

From rows of people three deep outside of the stadium in Lakewood, to a packed house of twelve thousand plus at Byers, the fans are loud and engaged. No matter the records coming in, this is the biggest game on the slate each year. Sometimes it is rainy, sometimes snowy, but the weather drives no one away and only adds to the excitement of the event.

It started in October 1952, when the Wildcats won, 41–12, and it has blossomed ever since. The Wildcats lead the all-time series, 33-28-1, but St. Edward has won 4 straight if you factor in the epic 2018 playoff game.

Despite the recent success of St. Edward in this rivalry, this series is about as even as it gets. The Eagles dominated for stretches in the 1970s and '80s, winning 13 games between 1971 and 1986. St. Ignatius began to take things over in 1988, winning 25 times between 1988 and 2018.

For St. Ignatius, it all begins and ends with head coach Chuck Kyle. Heading into the 2022 season, his last, the Wildcats were 360-104-1 in his thirty-nine years as head coach since taking over the team in 1983. Under Kyle, the Wildcats have won eleven state championships and graduated fourteen players who went on to play in the NFL. They are also 26-16-1 against St. Edward in the Kyle era.

With Kyle at the helm, the Wildcats are 74-27-1 after a loss. He reached the 100-win mark back in 2017 with a regional quarterfinal win over Perry. He has reached the playoffs in thirty-one of his thirty-nine seasons. Perhaps the most incredible feat next to eleven state championships is the fact that he has had only two losing seasons in thirty-nine years. His teams are 76-19 in the OHSAA playoffs.

In 2010, Kyle was inducted into the Ohio High School Football Coaches Association Hall of Fame and was also presented with the Lifetime Achievement Award that same year by the Greater Cleveland Sports Commission. In 2013, Chuck Kyle was inducted into the Greater Sports Cleveland Sports Hall of Fame. In 2016, he was inducted into National Federation of State High School Associations Hall of Fame.

The success of Coach Kyle and the St. Ignatius program has led to him winning the Ohio Associated Press Coach of the Year honor four times. Winning as a Wildcat is nothing new to Kyle, as he began his playing career with St. Ignatius in 1967 as a junior. Teams he played tailback on went 18-1-1 and captured multiple West Senate crowns. He even played a game at the Old Cleveland Municipal Stadium in 1968 against John F. Kennedy High School. He found the end zone in that contest.

It is no secret that there has been a long pipeline of St. Ignatius players going on to play at John Carroll, and Kyle was one of the first. But what many people don't realize is that he was a Musketeer before he was a Blue Streak. Kyle initially went to Xavier after graduation, but after one year there, the school ended the football program.

But it is the man people love, not just the winning record and coach. He agreed to write the foreword for this book within hours of being asked. He teaches safer tackling in Cleveland Browns youth clinics. He grew up in Cleveland and has had a beautiful forty-six-year marriage with his lovely wife, Pat. Together, they have raised four children.

Ironically enough, Kyle, who graduated from St. Ignatius in 1969, never actually played in the Holy War. For whatever reason, St. Edward was simply not on the schedule those four seasons.

He is a coach second, because he is an English teacher first. He values his time with the kids. To me, that means more than anything. He is a class act, and many of us have been honored to know him. What few people realize is that football is not the only sport for which he is an excellent coach. Under Kyle, the track-and-field team has won two state titles in his years with the program.

As mentioned, under Kyle, the Wildcats have collected eleven OHSAA championships since 1988, along with four national championships. Meanwhile, the Eagles have started to soar in the last twelve years, collecting five titles in that time (2010, 2014, 2015, 2018 and 2021), with current head coach Tom Lombardo at the helm for most of it.

A lot of fans consider the most memorable game of this rivalry to have taken place in 1993. It took three overtimes to decide the outcome. The Wildcats walked away a 35–34 winner that evening after an errant extra point for St. Edward cost them big.

The most memorable game in the rivalry that I covered was the "slush bowl" in the fall of 1996. Horrendous weather made it impossible to do much of anything until a kick was made in overtime to give the Eagles a crazy 12–9 victory. Current St. Edward radio color man Carmen Angelo would be quick to remind us that he was sick for weeks after that one, but the Eagle victory was worth standing hours in the freezing rain to watch. And stand we did. I fondly recall no one sitting for four-plus quarters in the stands.

Ed Daugherty is a St. Edward alumnus (class of 1992), but he began calling St. Ignatius football games in 2002 as part of ACP Productions, a company owned by Cleveland sports personality Al Pawlowski. This gives Ed a unique perspective on both sides of the Holy War. ACP Productions has broadcast every St. Ignatius–St. Edward game on the radio since 1997, including plenty of classics along the way. In his time with ACP, Ed has called games with Al, Mike Gibbons, Lenny Soeder, Bryan Hoffart and Frank Stams. From 2002 until 2015, he was part of the crew that broadcast every St. Ignatius game on local radio, and for the final nine years (2007–15) he was the lead play-by-play radio voice of the Wildcats.

Speaking of drama and high-pressure kicks, Ed Daugherty explains just how important is the legacy of great Wildcat kickers in the rivalry and in general for Coach Kye.

The kicking game at St Ignatius has produced some of the best moments in the school's history. The legacy goes back to current Wildcats head soccer coach Mike McLaughlin. As a senior, then-placekicker Mike McLaughlin connected on a 47-yard field goal against West Tech at John Marshall Field. It is the longest converted field goal in school history on grass.

As for long field goals, it's about as long as the list of quality kickers that have come through the school, dating back twenty-five years.

Jesse Milligan, Josiah "Juice" Kedzior, Nick Yako, Adam Danko, Tim Shenk (who went on to kick for the Air Force Academy), Matt Colella, Corey Griffith and Declan Mangan to go with Matt Trickett. Trickett holds the record for the longest field goal in school history, a 59-yard field goal versus Canton Glen Oak at Byers Field in 2017.

The kicking game has been something truly in the advantage column for the Wildcats in this series, especially since the mid-1990s….St Ed's has cultivated a few quality kickers, but not in the consistent lineage as the Wildcats.

I have been on the play-by-play call for seven of the ten longest field goals in school history. The most dramatic being Tim Shenk's 55-yard field goal versus Detroit (Mich.) Cody High School at Byers Field during the 2011 season.

In terms of the rivalry versus St. Edward, Shenk may have had the greatest stretch of games. In late October and early November 2011, Shenk kicked game-winning field goals against St. Edward twice in the course of three weeks—beating St. Ed's in week ten on October 29, 2011, at Lakewood Stadium and then two weeks later, advanced the Wildcats in the playoffs on to their eleventh state championship with a game-winning 32-yard field goal versus the Eagles at Brunswick Auto Mart Stadium.

That same season (Oct 15, 2011), Shenk made an extra point in overtime at Buffalo (N.Y.) St. Francis High School that defied logic, gravity and physics, giving the Wildcats a 21–20 overtime win.

It's hard to believe, but this game has reached extra minutes only four times in sixty-one meetings. The teams have split those meetings, with each school taking two. The most recent overtime thriller took place in the 2016 regional championship game as the Wildcats won, 38–31. The Wildcats reached the state championship game that season, falling to St. Xavier in overtime.

Speaking of playoffs, the schools have met four times in the postseason, with St. Ignatius holding a 3-1 lead in those games. The last two clashes in the playoffs have been incredible, in 2016 and 2018, and we will touch on both of those in a bit. They both came down to fantastic finishes.

This game has seen some incredible Wildcat performances over the years as well. In 2004, it was Andrew Stankus ripping off 222 big yards at Byers Field against the Eagles. Stankus would use that game to propel him to a great season, finishing with 1,339 yards. That is impressive, but still about 600 yards shy of the all-time single-season record held by Eric Haddad in

1993 (1,903). And no one will ever forget the cries of "Mike Buddy the ball carrier" over the loudspeaker in the late 1980s.

In 2015, Jack Cook caught 10 passes for the Wildcats in a 35–28 loss. That is still a school record for the Holy War. Also in 2015, Wildcat quarterback Dennis Grosel connected on 22 passes that night, another record in the rivalry. How about Scottie Mutryn, who tossed 5 touchdown passes in the triple-overtime showdown in 1993 with the Eagles? The game continues to bring out the biggest performances from the biggest stars in St. Ignatius history.

There is a laundry list of players from St. Ignatius who went on to play in the NFL. Here is that list, including the player's year of graduation. This list will continue to grow.

Ed Ecker, 1940
Joe Kantor, 1960
Brian Dowling, 1965
Oliver Luck, 1978
Chris Gizzi, 1993
Dan O Leary, 1996
Drew Haddad, 1996
Chris Hovan, 1996
LeCharles Bentley, 1998
Dave Ragone, 1998
Jacob Bell, 1999
Tom Arth, 1999
Anthony Gonzalez, 2003
Brian Hoyer, 2004
Dan Fox, 2009
Jake Ryan, 2010
Dre'Mont Jones, 2015
Liam Eichenberg, 2016

Meanwhile, St. Edward boasted nine players who have made it to the pros.

Kyle Shurmur
John Matlock
Tom Cousineau
DeJaun Groce
Rodney Bailey

Haruki Nakamura
Justin Staples
Kyle Kalis
Alex Boone
Andrew Dowell

Several stadiums have hosted the Holy War over the years, but perhaps the three locations that stand out the most are Byers Field in Parma, Lakewood Stadium and First Energy Stadium, which hosts the NFL's Cleveland Browns. All three are different and present their own levels of intrigue and fun. These stadiums don't include other venues that have hosted playoff games. Ed Daugherty talks about the uniqueness of playing at First Energy Stadium but also the drawback.

> *It is considered an Ignatius home game, and it is great for the kids to get that experience. It is also great for the fans once in a while, but it does lose something. My suggestion is to have games at the Hall of Fame Stadium, and the HOF Village when complete. They should play it down there every once in a while.*

Ed goes on to share what makes games at Lakewood great as well. "It has a great small-college feel, as it is locked in like Lambeau Field to become the Madhouse on Madison."

Byers Field at Robert M. Boulton Stadium is located at 7600 Day Drive in Parma. It was built in 1928 and saw major renovations in 1940, 1957, 1963, 1993 and 2013. It is the current home stadium of St. Ignatius and has been the house for countless Holy War games.

The 12,000-plus-seat stadium features three large press boxes and plays host to the home games of Parma, Normandy, Valley Forge and St. Ignatius. The natural grass was replaced with artificial turf in 1993. A new lighting system and bleacher improvements have been recently completed. One of the coolest aspects of the stadium is the giant video board at the north end.

The main press box was upgraded and can now sit up to thirty broadcasters and news writers. Parma City Schools invested nearly $1.2 million into the facility in the summer of 2014. This also made possible an expansion of the parking lot and made this the premier place for high school football.

Ed Daugherty has seen plenty of incredible Holy War games in all three locations and had several to talk about when asked for some of his favorites as a fan and announcer. He revealed some gems!

1993 – St. Ignatius 35, St. Edward 34 (3 OT)

I was able to find a ride home for the weekend from Xavier University—six of us (two St. Ed alums and four St. Ignatius alums) piled into a Ford Taurus and made the trip. What I remember about that game is that it was on its way to being another ho-hum St. Ignatius victory. The Cats had won four of the last five in convincing fashion, and the Wildcats were leading, 21–7, into the fourth quarter. (The only win was my senior year, a 14–10 victory.)

We were seated in the last section of bleachers on the Bunts Road side of Lakewood Stadium, closer to Madison Avenue, and that is where all of the magic happened that night. Eagles quarterback Bobby Adams led St. Ed's back to tie with a miracle throw in the final seconds of regulation, and the Eagles had forced overtime.

In the third overtime, I remember the high of St. Ed's taking a 34–28 lead, but the low of a missed extra point and then the emotional high of forcing the Wildcats into a third and long, only to see Scott Mutryn throw a game-tying touchdown that was nearly intercepted by St. Edward. And then one of the lowest points I have ever experienced leaving a football game. St. Ignatius converted the PAT and won the game, 35–34, in triple overtime.

2001 – St. Edward 44, St. Ignatius 41 (OT)

The first game in the rivalry that I "covered" as a reporter. A St. Edward 44–41 victory in overtime, blocking a St. Ignatius field goal.

2010 – St. Edward 33, St. Ignatius 10

I was broadcasting the game on WHK, with kickoff at 7:00 pm. But I was broadcasting a Case Western Reserve University versus the University of Chicago football game in Chicago in the afternoon. At the end of the CWRU/UC game, I hailed a cab to Midway Airport, took off at 5:00 p.m. (4:00 Central Time), landed in Cleveland and was out the door of baggage to meet my parents, who were driving me to the game. I made it to Byers Field, ran up the stairs and was in the press box at 6:56, just four minutes before kickoff, enough time to catch my breath and start the game. The evening was made nicer by the fact that my alma mater won the game, 33–10. It was one of the largest St. Edward victories in a generation.

2015 – St. Edward 35, St. Ignatius 28

> *It was a day game, and St. Ignatius just wouldn't go away as they kept coming back to keep it close as Ed's was looking for their second consecutive title. Sadly, a friend of my partner passed away listening to us. That was what he wanted.*

Ed gives his insider perspective as to why this is one of the best rivalries in high school sports.

> *As for the Holy War, the special aspects of it are both in the players and the alumni.*
>
> *Starting with the players—these boys have played for the same youth and CYO* [Catholic Youth Organization] *teams growing up. They could live next door to each other. These boys have attended the same schools, sat next to each other in class for up to eight years and then in the fall of their freshman year, they are lining up across the line from each other—tackle to tackle or wideout to defensive back.*
>
> *This is one of the main separation factors in the rivalry and why it is so different than others. Your best friend is now your main rival. This is not a border battle, like we see locally between Brunswick and Strongsville or Solon and Hudson or Avon and Avon Lake. This is not small school prep football like University School and Hawken.*
>
> *What makes this game special is legacy and generational between families, friends and neighborhoods.*
>
> *As for us alumni, we carry the tradition. We love the event—from the tailgates to the after-game parties. We pack the stadiums for this game every October. We tell time by the victories or losses, especially in our senior years.*
>
> *And the alumni are in every facet of your life in Northeast Ohio.... If you are wearing gear from one school or another, there is almost an expectation that someone will stop and ask about your grad year.*

The 2014 Eagles were one of the best teams in OHSAA history. In 2014, they won 6 of their last 7 games by 30 or more points, one of which was against their rivals, and 4 of which came in the playoffs on their way to a Division 1 state championship. The success led to the departure of Head Coach Rick Finotti to the University of Michigan Wolverine staff under Jim Harbaugh. It wouldn't take the Eagles long to fill the opening with Highland head coach Tom Lombardo.

St. Edward cheerleaders. *Julie Spisak Herzog.*

St. Ignatius pregame prayer. *Julie Spisak Herzog.*

St. Edward Eagle fans. *Julie Spisak Herzog.*

Growing up in the heavily Italian Collinwood area, Lombardo was a football fan and once idolized Doug Flutie. This fandom was to the point that he ran around his house pretending to be the quarterback after the famed Flutie "Hail Mary" touchdown pass in November 1984, when the Boston College Eagles defeated the seemingly invincible University of Miami Hurricanes.

He would go on to watch his cousin play high school football at Villa Angela St. Joe's and college ball at Wooster. He was so enthralled with the games that he would bring a notepad to chart the plays. He was destined to be a football coach from those early moments on.

His family moved to Mayfield when he was ten, and he eventually attended Gilmour High School, where he was a three-sport athlete in football, basketball and baseball. He is an avid supporter of kids playing multiple sports.

Lombardo started coaching in college after playing baseball for two years at John Carroll. He ended up coaching basketball for Gilmour, which went to the state finals in 1992. In 1995, he became the head basketball coach at University School in 1995. He has coached ever since, with head coaching stops at Lake Catholic and Highland in Medina.

It was a tough decision for Tom Lombardo to leave Highland. He had recently turned down a job at Massillon to replace Jason Hall, and that spot

went to Nate Moore. He planned on staying at Highland but eventually found St. Edward to be the perfect fit based on family reasons and his Roman Catholic upbringing. It was also a place for his sons to go. It was a faith-based decision.

Lombardo knew of the pressure coming in because of the incredible record and the roll the team got on in 2014. He was taking over a team that was scheduled to play the best schools not only in Ohio but in other states as well. Some media members said that St. Edward would be the best 3-7 team anyone had ever seen, but Lombardo and the Eagles had other plans. They would go an incredible 14-1 run and win another Division 1 championship in Lombardo's first season. It was a special year, and Lombardo found his home!

Lombardo got his first taste of the rivalry during the incredible 35–28 clash in 2015, won by St. Edward. He reflects on that day and the rivalry in general: "St. Ignatius is never down, they have such incredible players, and Coach Kyle is unbelievable. Just getting through that game and propelling us to the playoffs was huge. The kids know each other very well and the atmosphere is like no other."

If this rivalry wasn't incredible enough, sometimes you get the amazing luck of getting to watch it twice, as they hook up in the playoffs. This was the

Holy War action, 2021. *Julie Spisak Herzog.*

The Eagles celebrate a 2021 Holy War victory in the rain. *Julie Spisak Herzog.*

Julie Spisak Herzog.

The Eagles bring the beef on the line. *Julie Spisak Herzog.*

case as recently as 2016 and 2018. In 2016, it was a rematch of the teams' week 10 battle, which St. Ignatius won, 34–7. The second game was a bit closer, and St. Ignatius held on in overtime to win, 38–31, to advance to the state final four in Division 1, eventually losing to Xavier in a thrilling double-overtime state championship game.

It was an 8-yard touchdown rumble by Mark Bobinski on the first possession of overtime to give them the 38–31 lead. They would hold the Eagles to a four and out, and that put them in the final four. It was a wild finish to a back-and-fourth game that saw the Wildcats prevail.

I spoke with Coach Chuck Kyle before that game. He had this to say about the challenges St. Edward brings to the table each week:

> *They are a very good football team. They are well equipped on defense with a lot of good players who are quick. They use a variety of stunts to force a lot of second and longs. They run it well, they execute it well. Their offense can really spread you out. If we get on a one on one, we have to make a play. That's football the way that it is. We have to play every down and realize they will bring some wrinkles and we need to adjust to that since our last game again them.*

In 2016, St. Ignatius running back Mark "Bobo" Bobinski was unstoppable. *Author photo*.

Holy War action. *Julie Spisak Herzog*.

The Wildcats take the field. *Julie Spisak Herzog.*

The scoring began the second time St. Ignatius touched the ball. They had a long, methodical drive, using 2 passes to Travis Pot to set up a Mark Bobinski 2-yard touchdown run with just under five minutes to go in the first quarter.

St. Edward would use the no-huddle offense and several quarterback draws with Kevin Kramer to drive the ball down the field on their next possession. Coach Lombardo went for it on a fourth and goal from the 1-yard line, pounding it in for 6 points with Curtis Szelesta on the ground.

Moments later, on the next Eagle drive, Justin Sands of the Wildcats laid a huge hit on Kramer, jarring the ball loose and giving it right back to the Wildcats deep in St. Ed's territory. The Wildcats capitalized with a 32-yard field goal by Matthew Trickett. The Eagles stuffed three straight Stowers runs to hold them to a field goal.

On the very next drive, on a fourth and long, the Eagles used a fake punt to gain 20-plus yards to keep their drive alive. They got deep into Wildcat territory but couldn't punch it in. Then the Wildcats blocked their field-goal try.

The Eagles then forced a three and out but blew the chance to get the ball back when they muffed the punt on their own 18-yard line. The Wildcats recovered and took over in the Eagle red zone with 2:46 left in the half. This

Holy War game action from 2021. *Julie Spisak Herzog.*

Christian Ramos scores in the Holy War to put the Eagles ahead. *Julie Spisak Herzog.*

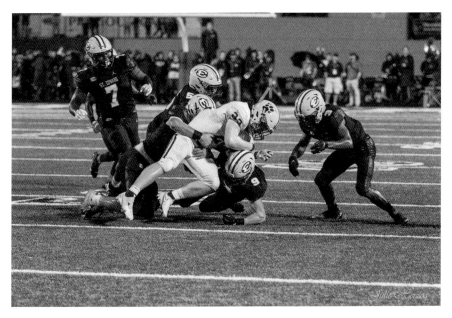

Action from the 2021 edition of the Holy War. *Julie Spisak Herzog*.

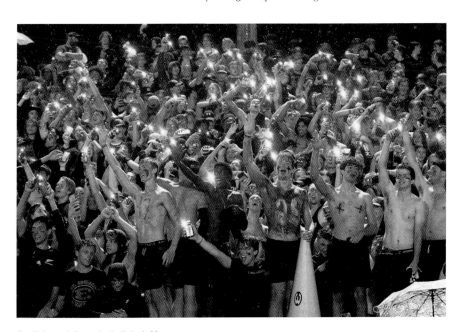

St. Edward fans. *Julie Spisak Herzog*.

time, the Wildcats cashed in on the turnover with a 7-yard Patrick Ryan quarterback draw for the touchdown, making the score 17–7.

The first-half scoring wasn't over yet. A 66-yard touchdown bomb from Kramer to Hoover made it 17–14, St. Ignatius, with eighteen seconds left in the half. The Eagles were lucky to be down only 3 points at the half, considering they had lost 2 turnovers and had a field goal blocked.

The two teams swapped touchdowns in the third and entered the final quarter at 24–21, with St. Ignatius ahead.

The Eagles capitalized on a huge fourth-quarter interception to take a 28–24 lead, only for the Wildcats to strike back plays later on the arm of Patrick Ryan to make it 31–28. As the Eagles got the ball back with minutes left in the quarter, a horrible injury occurred to quarterback Kevin Kramer. He had to leave the game after lying motionless for several minutes. The Eagles would settle for 3 and tie the game at 31 with four minutes to go. The game went into overtime in dramatic fashion.

Coach Lombardo reflects on that night and what may have happened had Kramer not gotten injured:

> That Saint Ignatius team that year was tremendous with one of the best defenses they have ever had. The Kramer play was a power read that went 50 yards. I went with my sophomore quarterback to replace Kramer following the injury, because I felt as though he had more experience, playing JV games and such. We had a chance late in the fourth quarter, but Mark Bobinski recovered his own fumble for them, and we couldn't pull it off.
>
> I was so proud of that team, because we had very few players coming back from the 2015 team. Maybe three or four players on each side, at most. As they practiced and got better, they gained confidence. It was just a hell of a game at Bedford, one of the best!

The two teams would clash again in the postseason just two years later, as St. Edward was in the middle of a state championship playoff run in 2018. St. Ignatius had beaten them, 21–7, at First Energy Stadium the week before to secure home field advantage in the game. St. Edward under Tom Lombardo had already won a state title in 2015 and appeared prime to appear in the title game again if they could get past their rivals.

Had St. Ignatius lost in the regular-season week ten matchup, St. Edward would have had the home field advantage in the playoff game. However, with the St. Ignatius win, the game took place at Byers and led to quite an interesting story in itself. Prior to the game starting, the St. Edward

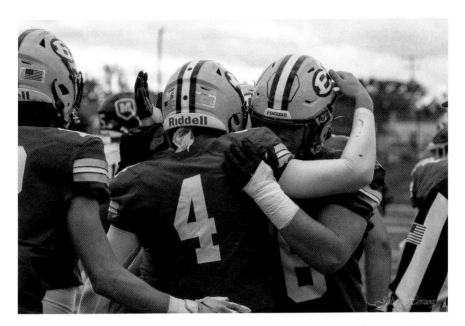

St. Ed's celebrates another touchdown. *Julie Spisak Herzog.*

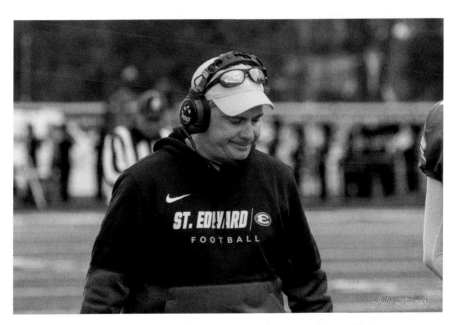

St. Edward head coach Tom Lombardo arrived in 2015 and has won multiple state championships. *Julie Spisak Herzog.*

The Wildcats claw Danny Enovitch. *Julie Spisak Herzog.*

Touchdown Eagles. *Julie Spisak Herzog.*

coaches noticed that their radio equipment up to the coaches' press box wasn't working. Per OHSAA rules, St. Ignatius was under no obligation to remove their own headsets and radio equipment. This would have given them a sizable advantage. Chuck Kyle chose to not use their equipment either, deciding it was the right thing to do. It was a class move by Kyle that only strengthens his legacy.

Tom Lombardo had this to say about it: "I have a lot of respect for coach Kyle, to his credit, not using their headphones. I always had a lot of respect and admiration for Coach Kyle for doing that. We would go on to win the state title after that."

Kee On Sports reporter Mike Trivisonno covered the game and has these memories of the incredible game that took place that night in the 2018 playoffs.

For me, I've covered teams like St. Edward, Mentor, Medina, St. Ignatius, Chardon and Hoban, just to name a few. My favorite rivalry I've covered is the Holy War. St. Ignatius versus St. Edward. The battle of two of the most prominent schools in Northeast Ohio. I've covered this rivalry many times, and it seems to get better each year.

There's a passion built up in these schools that is just unmatched.

These two teams met just one week earlier, at FirstEnergy Stadium in downtown Cleveland, where St. Ignatius came away with an impressive 21–7 win. They shut down the Eagle offense all night. Then comes week one of the playoffs, the very next week of the season, where these two teams meet again. This time, it's win or go home.

Both teams had to battle mother nature that night as rain impacted gameplay. Not ideal, but whenever these two teams meet, it's always a treat, starting with the student sections. Those of you that live in Northeast Ohio know that Byers Field in Parma is one of the biggest venues in the area. Filling out the stands on both sides requires a lot. Both of these schools nearly sold out the stadium, that's how much this rivalry means, especially in the playoffs. The student sections for both schools come prepared, a blackout versus a whiteout.

These aren't just two of the premier teams in the area, they're top-ranked in the state of Ohio as well, so you know you're watching some big-time athletes competing here. The game was back-and-forth to start the second half despite a low-scoring first two quarters. Despite the low score, it was a game of hard hits, big plays and very loud fans.

Trailing 14–7, St. Ignatius scored a touchdown thanks to an 86-yard kickoff return. The extra point was missed, and the Wildcats trailed, 14–13. Now the fourth quarter, St. Edward added on to its lead following a 2-yard touchdown run from quarterback Garret Dzuro. Down by 8 points, St. Ignatius had to travel 99 yards with less than four minutes remaining in the game.

The call was answered. A couple of big plays started the drive, and it ended with a 35-yard touchdown run from quarterback Patrick Delahunty. The score put the Wildcats within 2, 21–19, with less than two minutes left. The ensuing 2-point conversion failed, as Delahunty couldn't find an open receiver.

Ball game. St. Edward 21, St. Ignatius 19. The atmosphere in the closing four minutes of that game might be the most vivid memory I have of a playoff football game. Both student sections, all fans on the edge of their seats soaking wet trying to dodge each raindrop. Being on the sideline for those final minutes felt like an eternity. It was a feeling that every high school football player wants to be a part of.

The celebration was on. The Eagles—wearing their all-white jerseys—ran toward the whiteout St. Edward student section and celebrated. They sang. They danced. Some even cried. You'd think they just won the state championship game. To some players in this rivalry, it certainly feels like a state championship game each time these two teams meet. Securing the win—a playoff win in this case—to knock your rival out of the playoffs was something special. Especially since that team just beat you the week before.

That game was the epitome of high school football. For friends. For the parents. For the players. For the media members. High school football teaches lessons, and it shows that the game is much bigger than just one player, coach or play on the field. It takes a team and a special bond that'll always be remembered.

The 2019 edition was strange, as the game resulted in a 7–3 victory for St. Edward. It wasn't exactly the thriller we have come to know and expect. The next year, as we headed into the 2020 COVID edition of the Holy War, it took place at Cleveland Browns Stadium. Once again, it wasn't exactly a shootout, as St. Edward won, 17–0, but St. Ignatius did repeatedly shoot themselves in the foot during the game.

St. Edward was, very quietly, one of the best—if not the best—team in Division 1 that season, based on their defense alone. The team would bend

but not break, and they continued to show no fear in any situation, no matter the score or position on the field.

Mix that powerful defense in with a strong-armed and -legged quarterback in Christian Ramos, and the Eagles were looking for another deep run into the postseason.

St. Ignatius outgained St. Edward, 142 yards to 78, in the first half, but they still trailed, 7–0, because of several mistakes at the break. Jaxon French went 9 of 16 for 100 yards in the half, but again, it wouldn't matter, due to 4 turnovers and a missed field goal. The Wildcats squandered one chance after another in the first half, as the Eagles forced the Wildcats to fumble 4 times in the first half alone.

Those fumbles were mixed with a missed 27-yard field goal by St. Ignatius, and the half closed out with the score 7–0 Eagles. The Eagles had their lone score on a pass from Ramos to Malachi Watkins from 11 yards out in the front corner of the end zone.

The Eagles tacked on 3 more points to their lead on a 22-yard field goal from Noah Rios with 3:22 left in the third quarter. They then piled on 7 more in the fourth quarter, as Ramos broke three tackles on a 34-yard scamper to pay dirt in the opening moments of the quarter.

The Holy War, 2021. *Julie Spisak Herzog.*

Holy War action. *Julie Spisak Herzog.*

The Wildcats take the field for the Holy War. *Julie Spisak Herzog.*

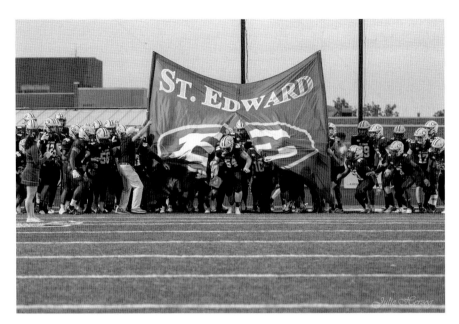

St. Edward Eagles take the field. *Julie Spisak Herzog.*

A bit later, a C.J. Hankins interception sealed the deal for St. Edward and closed out the 17–0 victory. Emmett Hanna of the Wildcats also had a pick at the 1 that could have resulted in another score for St. Edwards.

Play-by-play man Ed Daugherty looks back on that weekend and the overall dominance by St. Edward: "It was a strange year, but St. Ed's shutout St Ignatius on all three levels. Freshman, 34–0; JV, 7–0; and varsity, 17–0. First and only time it has happened for the Eagles. I attended the freshman game to watch my son, we watched the JV on the stream and I called the varsity game."

St. Edward coach Tom Lombardo explains why he was happy his team won but also the subtle differences that make playing at Lakewood better than at First Energy.

> *Playing at the Browns Stadium is great for the kids and the fans. The problem is one year we had as many as 18,000 people there and it still looked empty considering it is a 72,000-seat stadium.*
>
> *I think at Lakewood Stadium the game is most electric, because the stands are packed and it is standing-room only. I love the game at Lakewood, because there is nothing like walking out for warmups with the team and seeing the stands already packed. It is tremendous at the Madhouse on Madison!*

The sixty-second annual Holy War, in 2021, appeared to be a mismatch in favor of St. Edward, but, as always, the game on the field was different from the game on paper. This one didn't disappoint, as St. Ignatius traveled to Lakewood Stadium to take on top-ranked rival St. Edward in front of a frenzied crowd at the Madhouse on Madison. It was a sloppy game at times, but St. Edward did more than enough to pull out the 19–14 victory.

St. Edward quarterback Christian Ramos had an up-and-down night, throwing for 124 yards on 11 of 21 passing with 2 interceptions and 1 touchdown. He did the most damage with his legs, rushing for 100 yards on 17 carries. He also extended several drives with key third-down pickups.

His backfield mate Danny Enovitch put together a nice performance against the stout rush defense of St. Ignatius. He went for 77 yards on 16 carries and picked up a lot of tough yards along the way. Enovitch also caught 1 pass for 4 yards on the evening.

St. Ignatius struggled for any significant offense outside of Marty Lenehan once again. The stud tailback went for 87 yards on 19 carries. He could have had more than that, but for whatever reason, they went away from him in the third quarter and in early parts of the fourth. This was the same stretch that they pulled starting quarterback Pierce Spencer in favor of Patrick Tompkins.

Spencer, who was playing for injured normal starter Joey Pfaff, went 6 of 11 for 100 yards and 1 touchdown and 1 interception. However, 69 of those 100 yards came on a screen pass that Max Muresan took 68 of the 69 yards. Also, St. Ignatius struggled to move the ball in the first half, so perhaps that was part of the reason for the switch to Tompkins.

The problem for the Wildcats was that Tompkins was not effective, going 2 of 9 for 9 yards and 1 interception. They tried using him in a wildcat formation at times, but that was also not effective, and he was held to -1 yard on 6 carries. The Wildcats hoped to have Pfaff back by the Xavier game, if not by the playoffs.

After forcing a three and out, the Eagles started their first drive with good field position. However, before the Eagles could punch it in, it was St. Ignatius Wildcat John Mangan picking off Ramos to snuff out the drive. Later in the quarter, St. Edward went for it on a fourth and short at midfield and didn't get it. The first quarter ended scoreless.

The scoreless first quarter gave way to a wild second quarter of action. After St. Ignatius missed a 35-yard field goal, the Eagles got the ball back but couldn't do anything with it. St. Ignatius muffed the punt and gave the ball right back to the Eagles. Moments later, it was Ramos hooking up with

Holy War action. *Julie Spisak Herzog*.

Holy War action. *Julie Spisak Herzog*.

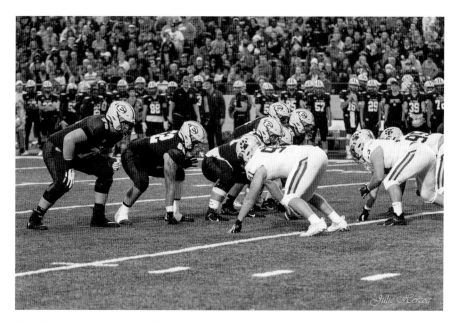

Holy War action. *Julie Spisak Herzog*.

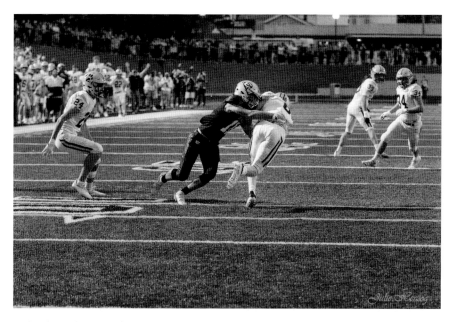

Holy War action. *Julie Spisak Herzog*.

Rayshawn Manning Jr for a 36-yard touchdown for the game's first points. They would miss the extra point, and it was 6–0 Eagles.

Then, less than fifteen seconds later, it was St. Edward's Jack Riley picking off Spencer and taking it to the house to make it 12–0 in the blink of an eye. The score remained 12–0 after a failed 2-point conversion.

Late in the second quarter, it looked as though the Eagles would set up shop to score again after they blocked the St. Ignatius punt and took over at the Wildcat 42. But the Wildcats had other ideas, as Griffin Taliak picked off a Ramos pass to give the ball right back to the Wildcats.

The second quarter became even zanier, as the Eagles appeared to get the ball back up 12–0 when they forced a punt. The problem was that they got a little overzealous and ended up roughing the kicker. This led to the Wildcats scoring on the next play on the 69-yard screen pass to Muresan to make it 12–7 at the half.

Still up 12–7 as they entered the fourth, the Eagles scored again as Ramos connected with wideout Jackson Miller on a beautiful pass in the corner of the end zone to put the Eagles up, 19–7, with 10:59 to go.

The score remained 19–7 until the waning moments of the game, when St. Ignatius blocked a St. Edward punt with twenty-eight seconds to go, and

St. Edward quarterback Christian Ramos. *Julie Spisak Herzog.*

Danny Enovitch ran the Eagles to a 2021 Holy War victory. *Julie Spisak Herzog.*

St. Edward Eagle Joshua Gribble. *Julie Spisak Herzog.*

Joe Norris returned it for a touchdown. Just like that, a game that appeared to be over was suddenly in question, as it was 19–14. St. Edward was able to recover the onside kick and win the game.

I'll say it again, this was a wild game when you look at the big picture. There were 4 total interceptions, 1 muffed punt and 2 blocked punts. The Wildcats were down only 12–7 in the third quarter and got the ball twice in Eagle territory to start drives but couldn't do anything with it.

Sometimes in a game, it is the little things that stand out when you go back and look at it. St. Ignatius missed 2 field goals from 35 yards and 53 yards. That didn't seem like a big deal at the time, but had they made both of those, they would have won, 20–19. St. Edward didn't care about any of that, however, and would go on to win the state championship in 2021 over Springfield.

There have been sixty-one incredible matchups since the rivalry's inception in 1952. There is a win differential of just 4 games, and the teams have combined for sixteen state championships. Again, you can talk to me all you want about Massillon versus McKinley, and it deserves the praise it gets. But for my money, this is the greatest rivalry of all time.

St. Edward coach Tom Lombardo sums it up best: "It is a tremendous game no matter the records or stats coming in. When you add in the fans and the excitement, there is nothing like it! There is a ton of respect for everyone involved. How can you beat that? You can't!"

THE SILVER RAIL

Avon vs. Avon Lake

A von and Avon Lake, two of my favorite cities to cover in high school athletics, are two cities filled with passionate, supportive and knowledgeable sports fans, as well as great coaches, great athletic directors and great parents. It's impossible not to like either one of these cities, but when they play each other, the hatred and competitiveness is so thick you can feel it from outside of Lorain County. Make no mistake about it, folks, this is the rivalry that put Kee On Sports on the high school football map.

For more years than I can count, Avon Lake dominated the Southwestern Conference (SWC) with one run to the playoffs after another, including a state title in 2003 and a state runner-up crown in 2004. The Shoremen have more than 557 wins since 1939 and 260 wins in just the last thirty seasons alone. They have won a whopping thirty-nine conference championships, including twenty-one of the last thirty-six SWC conference championships. They have made twenty-two trips to the playoffs in that stretch, twenty coming in the last twenty-six years. For years, the SWC ran through Avon.

Then, an interesting thing happened, Mike Elder showed up in Avon and took over the Eagles, and suddenly, we had one hell of a rivalry on our hands. The two teams have played yearly since 2010, and starting in 2012, Avon became a member of the SWC, making things even more interesting.

First, let's step back just a bit. The two teams didn't play each other once from 1960 to 2007, but when the decision was made in 2010 to make this a yearly game, combined with the conference switch of Avon in 2012,

Mason Wheeler was a force in the Silver Rail Rivalry for Avon Lake. *Author photo.*

there was no chance this wasn't becoming one of the most heated rivalries in the state.

It's a border war if there ever was one. You can leave Avon Lake High School's parking lot, take a left, and you're in Avon within minutes. That is, if you don't decide to stop off at one of the many eateries on the way.

In 2015, I got my first real taste of this rivalry and was instantly hooked. Ironically, it was the same year the rivalry got its official name, the "Silver Rail Rivalry," an allusion to the train tracks that run through both cities. It even came with a shiny new trophy, courtesy of the Avon Lions Club. The idea actually came from an Avon Lake resident, according to sources with the club. Either way, it was a cool idea.

We pick up this rivalry heading into 2015. At that point, the Eagles had won four of the previous five matchups dating to 2010. Again, this would be my first taste of the rivalry as a reporter, in only the second game I covered. I would learn quickly just how important this game was to everyone involved.

September 4, 2015 was week two of the season. Avon quarterback Jake Sopko led the charge. The host Avon Eagles soared past Avon Lake to win the brand-new Silver Rail trophy in their Southwestern Conference debut. The senior and future University of Cincinnati Bearcat Sopko threw for 272

yards and 3 touchdowns and ran for another. He was instrumental in the Eagles' 31–7 victory.

Avon took an early lead and never looked back as they forced the Shoremen to punt on their first drive and scored on their first possession with a 21-yard touchdown pass from Sopko to senior Will Heilman. The Eagles then caught their rivals off guard as they sneaked a successful 2-point conversation to go up, 8–0, with 3:02 left in the first quarter.

Avon Lake failed to score on its next drive, even after a costly Avon roughing the passer penalty on a third and long kept the drive alive for the Shoremen. The next punt by Avon Lake's Patrick Beckman looked to turn things around, as it placed Avon at its 1-yard line. But all it led to was an impressive 99-yard drive by the Eagles, breaking the back of the Shoremen. A few plays later, Avon running back Gerett Choat broke a 67-yard run to place the Eagles right back in scoring position. Shortly after, a Sopko touchdown run from 5 yards out put Avon ahead, 15–0.

The Eagle's Nest was going absolutely nuts as every break seemed to be going their way. It would continue for Avon and get worse for Avon Lake. Moments later, following an Avon safety, it was Choat taking a screen pass 54 yards for a touchdown to give Avon a 24–0 lead at the half. It was a blitzkrieg of Eagle offense that saw them score 9 points in nineteen seconds to close the half. By the time the bands hit the field and the flag girls started twirling, this one was already over. A perfect time to stop by the snack stand and get those Krispy Kreme donuts the boosters love to sell.

The only question was how soon Avon would start the running clock on Avon Lake. In the OHSAA, once a team goes up by 30 in the second half, a running clock is employed that only stops on turnovers and scores.

Jake Sopko must have been aware of this, because he wasted no time putting the Eagles up, 31–0. The Eagles continued the scoring with a 25-yard touchdown pass from Sopko to Heilman to open the second half. The clock began to run nonstop from there, and the Krispy Kreme donuts were tasting just a bit sweeter in the stands for the Eagle faithful.

Avon Lake had to play for pride at that point, doing what they could to avoid being shut out by their rivals. Late in the fourth quarter, with only a few minutes left, they got on the board with an 8-yard pass from to Carson Toy, avoiding the shutdown in the 31–7 defeat.

Looking back, it was my first experience not only with the rivalry but also with Avon. I was blown away with the energy of the crowd and by how much fun it was to cover that game. I really thought Sopko had a bright future in college, but it would teach me that a great SWC high school career

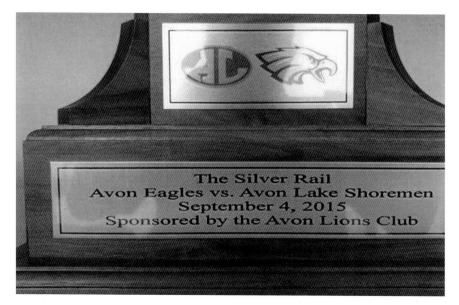

The Silver Rail Trophy was created in 2015. *Author photo.*

doesn't guarantee success at the NCAA Division 1 level. And that's no knock on Jake. The young man was dynamic and humble. It was just a learning lesson for me personally on the extreme jump in talent from high school to Division 1 college.

Avon head coach Mike Elder had a tough choice on his hands coming into the 2016 edition of the crosstown rivalry game for the Silver Rail Trophy. His team ventured to Avon Lake to take on the Shoremen in front of a hostile crowd that was screaming with forty-five minutes to go in pregame warmups.

The choice for Elder was between staying with the hot hand of sophomore sensation quarterback Ryan Maloy and continuing to rest original starter Matt Kelly, who went down to injury in the preseason, or starting Matt Kelly and letting the senior lead them. Coach went with the senior, and it paid off with a 31–7 victory.

Both players would get their chance to shine, however, and both awarded the coach's faith and led the Eagles to a big win over the Shoremen. Kelly passed for 84 yards on 3 of 6 passing and 1 touchdown. He also had runs of 4 and 9 yards, including a touchdown on the ground.

Malloy went 3 of 5 for 69 yards and ran for a touchdown. He showed off his legs with 43 yards on the ground. He brought the aura of mobility the coach wanted from him.

Helping take the load off Kelly and continuing to impress was senior running back Mason McLemore, who had big shoes to fill after Gerrett Choat graduated the year before. McLemore ran for 74 yards on 15 attempts. He also scored on an 11-yard catch. Not to be ignored was Avon junior running back Tony Eberhardt, who had 4 carries in the third quarter for a whopping 105 yards and 1 touchdown.

Coach Elder explained his choice of going with Kelly but also the choice to split time with Malloy: "Our Senior Matt Kelly had earned that right to be our starting quarterback. He played behind a great player in Jake Sopko for two years and learned behind him. He also led the JV team to back-to-back unbeaten seasons."

Elder also had high praise for his sophomore back up, Malloy: "The kid is one of the most athletic players I have ever coached, and he too earned the playing time we gave him. He brought an added element to the game with his legs and can make any throw on the field."

Avon Lake quarterback Matt Pappas was also very active, throwing for 149 yards on 16 of 30 attempts, but it wasn't nearly enough to help the Shoremen. His main target was Carson Toy, who finished with 89 yards on 7 catches.

The scoring began in the first quarter, when Avon Lake jumped ahead, 7–0, on a Carson Toy 1-yard touchdown off a direct snap to him. The drive had been kept alive by a costly pass-interference call on the Eagles at third and 17 for Avon Lake.

The first quarter ended with Avon Lake up, 7–0. It was a sloppy quarter that saw each team commit 3 penalties. The first quarter also saw both quarterbacks struggle. Avon's Matt Kelly went 1 of 4 for 18 yards, while Avon Lake quarterback Mark Pappas went just 3 of 9 for 30 yards.

The Eagles got on the scoreboard early into the second quarter following a blocked punt, which gave them the ball at the Avon Lake 4-yard line. Elder inserted his versatile sophomore Ryan Maloy to sneak it in for the score to tie the game.

The Avon Eagles then made the best of a two-minute drive led by sophomore sensation Ryan Maloy to close out the first half with a Mitch Cooper 27-yard field goal as time expired. Cooper had just caught a 45-yard strike from Maloy a play earlier to get them the last-second kick with four seconds to go. It gave the Eagles a 10–7 lead headed into the half.

Coach Elder went back to his senior to start the second half, and it instantly paid off with a 45-yard passing strike to Will Kocar to set up a touchdown run, also by Kelly, to give the Eagles a 17–7 lead.

The Avon Lake Shoremen defined Kee On Sports in its earliest years. *Author photo.*

Avon got the ball right back and marched down the field on the strength of 3 runs totaling 72 yards by junior running back Tony Eberhardt to give the Eagles a commanding 24–7 lead. Eberhardt saw his first carries of the game and made the best of them.

Minutes later, the Eagles got the ball back and went on the attack. Maloy capped it off with an 11-yard touchdown pass to running back Mason McLemore. This blew the game open and made it 31–7, Avon over Avon Lake. This brought the third quarter to a close; the Eagles outscored the Shoremen, 21–0, in the frame. The game would finish with the same score.

Little did I know at the time that this rivalry would be the catalyst to launch Kee On Sports Media Group and pretty much define my high school sports writing career. I got a taste the year before, when Jake Sopko and the Eagles destroyed the Shoremen at home. But Sopko was gone now, and legendary head coach Mike Elder had a serious choice on his hands.

Ryan Maloy wouldn't get the start that night, but he too would go on to become a player I covered on a regular basis as the years went on. When it comes to football, who doesn't love a quarterback controversy? It was my first taste of one at that level, and I loved it!

I remember thinking when Avon Lake got up early that perhaps the tide was turning in favor of the Shoremen. But that proved to be false for several

The Avon Lake Shoremen get ready for the 2018 Silver Rail game. *Author photo.*

years to come. I also remember thinking that Matt Kelley may have gotten the job done that night, but it would soon be Maloy's gig.

The Avon Lake stadium was so loud that night; it felt like I was at a pro stadium. It was an amazing atmosphere. My love of the rivalry was taking its first steps and beginning to grow. That game turned into a blowout, but in a rivalry game like that, it was still electric until the final snap.

Two months later, the teams met again. This time, everything was on the line. The Avon Lake Shoremen traveled to the "Nest" to take on the Avon Eagles in first-round playoff action. It was hard to fathom that this game would be close after the earlier blowout, but Avon Lake was on a mission and had fate on their side.

In a game that would be talked about nonstop afterward, the Avon Lake Shoremen stunned the Avon Eagles, 27–26, ending their perfect season with a wild finish in a first-round playoff game in Avon. It was the first postseason scrap between the two squads since the inception of the rivalry, and it didn't disappoint.

Avon Lake raced out to a 7–0 lead in the first quarter as Mark Pappas connected with Jason Sullivan for a 9-yard touchdown. The Eagles were unfazed in front of their home fans and answered back quickly. Firmly planted senior starter Matt Kelly found Mitch Cooper for a 44-yard touchdown pass.

From left to right: Gage Duesler, Michael Corbo and Matt Oehlstrom during pregame at the Silver Rail in 2019. *Author photo.*

The Shoremen caught their first major break of the game, however, when Cooper missed the extra point, keeping the Shoremen in the lead, 7–6.

It wasn't a good night for Cooper. A bit later, the Eagles had a chance for a 40-yard field goal, but the kick was blocked. These crazy plays set the stage for what was to come.

Avon took control of the game, scoring 17 unanswered points to lead 23–7 with just under eleven minutes to play in the third quarter. It looked as though they had finally broken through and were starting to once again show their dominance, just as they did when the two teams hooked up in week two, when the Eagles won, 31–7. Both Eagle touchdowns came on the legs of tailback Mason McLemore.

Avon Lake refused to go away without a fight. Yes, it was a playoff game, but at the same time—and even more of a motivation—it was their rivals, dammit! The comeback began midway through the third, when Pappas connected with Denny Burns on a 9-yard passing touchdown to make it 23–13.

The mojo in the air was slowly but surely turning maroon and gold, as Avon fumbled on the ensuing kickoff, setting up the Shoremen at the Eagles' 34-yard line. From there, it didn't take Pappas long to find Carson Toy for a 34-yard touchdown pass to cut the deficit to 23–20 with 6:38 left in the third.

Still up by 3, the Eagles were driving near the Avon Lake 35-yard line when Kelly got knocked out of the game with an injury. Suddenly, like the Browns in 2002 with Kelly Holcomb and Tim Couch, the Avon Eagles would have to go to their popular backup in a playoff game against their main rival.

The young and hot-handed Ryan Maloy entered the game and led the Eagles into field-goal range, setting up Cooper for a 43-yarder to make it 26–20 with three minutes still to go in the third quarter. The Eagles were leading by 6, but there was still a lot of time to play.

Avon Lake's offense continued to roll. Tyler Nelson punched in a 2-yard rushing touchdown to give the Shoremen a 27–26 lead. What seemed improbable at halftime was sudden reality, as most fans sat stunned in their frozen seats as Avon Lake now led.

The Eagles took their time but then moved into scoring position with a chance to take the lead with 6:45 to play, but rather than kick what would have been a 37-yarder, the Eagles opted to go for it on fourth down and short and were denied at the line of scrimmage by the Shoremen defense. The Eagles passed up on a kick from Cooper, who had been struggling that night. This decision by Elder proved to be an omen for the rest of the game.

The Avon Eagles were so well coached that you just knew they would get another crack at it. And that's exactly what happened, as their defense held the Shoremen and got the ball back with 4:30 to play. They started at their own 30, moving slowly but effectively down the field into the red zone.

The Eagles needed just a field goal to win the game. It almost seemed like a sure thing, as Avon had the ball at the Shoremen 9-yard line with 1:03 remaining. The Eagles could run down the clock if they chose and then kick a 25-yard field goal to win it. Instead, with a kicking game that was shaky that night, Elder and the Eagles went for the touchdown.

At first glance, it wasn't a bad idea—until they decided to throw the ball. The Shoremen broke through the line and forced a scrambling Maloy to throw an interception in the end zone as the ball sailed into the hands of safety Andrew Butrey to seal the Shoremen victory.

Looking back on it in the winter of 2022, it took stones for Elder not only to pass up on the field goal but also to take it one step further and have his sophomore backup quarterback throw the ball. Elder is a great coach for a reason: he leaves nothing to chance and trusts his players, from number one to number fifty-one. Given the situation, I wouldn't put it past him to do it again. It didn't work out that time, but there is always a next time.

Avon Lake had many speedy threats on both sides of the ball. *Author photo.*

Heading into the 2017 season, the Shoremen saw a change at head coach, as Dave Dlugosz decided to retire. The reins of the historic program were turned over to thirty-two-year-old former Avon Lake Shoremen Matthew Kostelnik.

The new coach had grown up in Avon Lake, idolizing such sports stars as Sandy Alomar, Mark Price and Troy Polamalu. He played wide receiver and safety for the 2003 state champion Avon Lake Shoremen. From there, he went to play at Mount Union, where he was on two national championship teams as a player and one as a coach. Kostelnik brought a winning tradition with him to the Shoremen.

He explains why playing for Avon Lake helped him in college and also why he decided to return and coach at Avon Lake:

> *Mental toughness. During those days you had to wait to play at Avon Lake. It was rare that a sophomore saw the field. Combine that with the success of the program Coach Dlugosz set me up to be successful.*
>
> *Coach Kehres offered me a job coaching linebackers in the spring of my senior year. Spent two seasons with the Raiders and got a job at Notre Dame College. My three seasons there I was recruiting coordinator, LBs, safeties, and my last season, I was defensive coordinator. The next two*

years were spent at Beachwood as defensive coordinator. Came home after that, spending one year as an assistant and one year as offensive coordinator before taking over as head coach.

I enjoy helping kids, and this was the next logical step in the process. The opportunity to take over your alma mater is an incredible way to give back to the community and program that helped me on my path in life.

It gets overlooked how lucky I have been to take over an established program with a rich history like Avon Lake. Tweak a program, rather than having to build something new, is such an advantage to early success and continued positive growth. Coach Dlugosz has helped me so much along the way, taking my calls whenever I need him. I think the motivation to keep building on the strong foundation that Coach Dlugosz and the other Shoremen coaches built is pressure worth having.

As we began 2017, the Avon Eagles were led by Maloy and the sudden sensation at running back, Nick Perusek, in a game they had thought about nonstop since the previous November, when an errant pass ended an unbeaten season.

The teams traded early touchdowns. Avon used a four-play, 30-yard drive to set up a Tony Eberhardt 8-yard touchdown scamper. The Shoremen wasted no time answering, bolting 82 yards in ten plays, capped off by a 10-yard run from quarterback Jack Mikolich to pay dirt. The Shoremen missed the extra point, however, and they never recovered, as it was all Eagles from then on.

The Eagles would not let up. On the ensuing possession, Avon drove 63 yards on twelve plays, scoring on a 4-yard run by junior running back Mark Steinmetz to make the score 14–6. Minutes later, after forcing a three and out, the Eagles were back on the attack and looking to end all doubt. They did just that, driving another 93 yards and capping it off with a 19-yard touchdown pass from Maloy to wideout Kyle Kudla to give the Eagles a 21–6 lead. From there, it was their quarterback-placekicker David Orlando accounting for the next 10 points to put the game out of reach, 31–6, by halftime.

In his first start of the rivalry, Ryan Maloy finished the night going 10 of 13 passing for 106 yards with a touchdown and a pick. Nick Perusek took over in the second half, running 15 times for 88 yards and showing everyone just how good he could be.

Matthew Kostlenik talks about his first taste of the rivalry as the head coach in 2017:

My first taste of the rivalry was back in 2015 as an assistant coach. As a player at Avon Lake, we never played Avon, and to see what Coach Elder and his staff had built was impressive, to say the least.

As head coach, preparation in mindset to get ready for that game is crucial. The kids know how big the game is and how many people will be there, but we have to attempt to simulate that level of physicality and pressure in practice. After the butt kicking I took that first year, I realized that we had to up our game. I think that doing our best to simulate the physicality and pressure of the rivalry is the most important thing we can do to prepare for the big game.

Despite the result of that game, the 2017 Avon Lake team had plenty of growth and got better as the season went on. Among the reasons for that were the play of quarterback Jack Mikolich and running back Konnor Riggs. Coach Kostelnik touched on their growth that season: "Both young men are fantastic, hardworking kids. More importantly was their leadership in the weight room in the off-season. Combine that with a Ryan Beckman up front and you have a recipe for success."

Heading into 2018, the winds of change were blowing in favor of the Shoremen, as a thrilling finish brought them their first regular-season victory in the rivalry in years. Avon Lake scored on a Jack Mikolich quarterback sneak with thirty seconds left to give the lead to the Shoremen, 31–28. Avon had overcome a 24–14 deficit with under four minutes left to come back and almost shock the Shoremenm, 28-24, but they left two minutes on the clock, and the Shoremen rallied in dramatic fashion.

Konnor Riggs had a big night once again, finishing with 180 yards on 32 carries. Riggs was a key factor on every Shoremen touchdown drive that evening. He wasn't the only Shoreman to have a big night, as the team received solid quarterback play out of Jack Mikolich, who finished with 3 touchdown passes on 15 of 26 passing for 215 yards. He also had 2 touchdown passes called back on penalties. He had the winning touchdown with his feet as well.

The biggest threats for Mikolich were Luke Fedders (3 catches for 87 yards and 1 touchdown), Cole Schraff (5 catches for 55 yards) and Nathan Sidoloski (5 catches for 62 yards and 2 scores).

Avon Lake started the game on the Avon 40-yard line after a short punt on the Eagles' opening possession. After a first down, they had to settle for a 43-yard field goal by Harry Hebert. Coach Kostelnik explains the hot start of the Shoremen that night: "Looking back it was our ability to run the ball

effectively, win third down, and match physicality that were the keys to that game. Riggs and the O Line were able to hit their stride early in the game, and Jack delivered some big third-down plays."

The Eagles would switch to the hurry-up offense on their next possession. It worked well, as they wasted no time in answering the Shoremen score with a 1-yard Mark Steinmetz touchdown rumble. The score was set up after a key fourth-down-and-10 conversion on a Steinmetz catch.

The Shoremen were backed on the strong legs of Konnor Riggs, who dominated the Eagle defense on the ensuing drive. Riggs had 4 carries of 8-plus yards each on the drive to put his team in the red zone. The only pass of the drive resulted in a touchdown, as Jack Mikolich hooked up with Nathan Sidloski from 18 yards out to give the Shoremen the lead, 10–7, as the first quarter ended.

After another impressive defensive effort by the Shoremen that forced the Eagles to have a three and out, they had two separate touchdown passes called back due to penalties. The third would be the charm. Once again, it was Mikolich connecting with Sidloski for pay dirt. This time, it was a strike from 29 yards out to give them the 17–7 lead midway through the second quarter. The half would end with that score.

A scoreless third quarter set up a dramatic fourth quarter. Ryan Maloy would not go down easy, scoring on the opening play of the quarter with a beautiful 5-yard run that saw him spin off several tacklers. The scamper cut the Shoremen lead to 17–14.

The hopes of an Eagle comeback appeared to end shortly after, however, as Mikolich launched another touchdown pass. This time, a 46-yard bomb to Luke Fedders "appeared" to put the game out of reach at 24–14 with eight minutes to go. But we were just getting started.

The Eagles would have a last-ditch effort, as Steinmetz powered his way down the field, racking up over 50 yards on one drive to find the end zone again. The Steinmetz power attack cut the Shoremen lead to 24–21 with 3:35 to go. Steinmetz, who received extra carries in place of the injured Nick Perusek, finished with 108 yards and 2 touchdown runs.

In shocking fashion, the Shoremen fumbled the kickoff, giving the Eagles one last chance. Maloy and the boys didn't waste it. A few plays later, it was Maloy hitting a wide-open Joey Allen to put the Eagles up, 28–24. It was a lead that everyone thought was safe—before the last-second dramatics of the Shoremen.

Coach Kostelnik explains what he was thinking during the wild Avon comeback that gave his opponents a sudden lead:

As coach you have to show that you can be calm in these situations. Kids feed off of leadership, and I really hand it to our seniors in that moment. They knew what they wanted and went out and took it on that last drive. Coach Gerace called a great final drive, and the boys executed, plain and simple.

Jack had several come-from-behind victories in the final two minutes the year before, so his ability to lead a drive was never in doubt. As I said about the season before, we were five plays away from being 9-1, but we were also five plays away from being 3-7. As Coach Gerace always said, getting that opening first down is always the toughest. Once we got rolling, you could see Jack's confidence rising.

Both Luke Fedders and Konnor Riggs are great young men. If you gave Konner the ball hoping to get 2 yards, he would get you 5. Luke could always be relied upon to make a big play. Another wonderful young man that had an incredible work ethic and was crucial not only on offense but on defense as well.

For unknown reasons, the game was moved to week one starting in 2019. It wasn't pretty by any stretch, but the Avon Eagles clawed out a 13–12 victory to reclaim the Silver Rail Trophy. Both teams played like it was their first game, as neither looked impressive on offense. It was a defensive battle all night.

Coach Kostelnik touched on the challenges of playing one's rival in week one:

Playing week one, our disadvantage is our depth. They have more kids than we do (working on changing that), and they do a great job getting their twos and threes ready to play. Advantage of that is recovery. We had a lot of injuries that first game that we were able to recover from.

We know it will always be a physical game no matter when it is played, and weeks one through three are always the toughest as far as being in shape to play. Every year brings its own challenges, and as a coach you have confidence in your ability to get these young men ready to rock.

Avon Lake had graduated their incredible quarterback–running back combo of Jack Mikolich and Konnor Riggs of the year before. The team was hopeful that the new starters could pick up where those players had left off. They did their best, but it made for a long and scrappy night, as Matthew Kostelnik rotated between senior Harry Hebert and junior Michael Corbo.

The Shoremen went with a dual quarterback attack as both players rotated in and out. Starting behind center was Harry Hebert, who went 6 of 8 for 74 yards and was sacked 3 times. He did his best damage with his legs

and feet, running for 23 yards on 6 carries and kicking two crucial field goals that gave the Shoremen a late lead, 9–7, and then 12–7.

Leading the two drives that resulted in those Hebert field goals was Michael Corbo, who threw for only 30 yards and 1 interception on 3-of-10 passing. To his credit, Corbo did hit several wideouts right in the hands; they simply dropped the ball. Where Corbo did his best work was on the ground, running for 78 yards on 5 carries.

Coach Kostlenik talks about the quarterback combination and the battle for the starting spot coming into the season: "It was extremely hard to choose between those two fine young men. We were prepping for two different quarterbacks in our offense, which presented its own set of challenges. Both men handled it well, and it's a testament to their character more than anything else."

Replacing Konnor Riggs in the backfield was Gage Duesler, who ran for the only Shoremen touchdown. He totaled up 53 yards on 12 carries. Avon had many of the same problems Avon Lake did trying to move the ball. First-year quarterback Danny Zeh, who was taking over for Ryan Maloy, struggled at times. Zeh went 15 of 22 for 146 yards with 1 touchdown and 1 interception and tasted the turf, suffering 4 sacks.

Zeh's touchdown pass was a 1-yard dumpoff that running back Nick Perusek took 23 yards for the score. It was Avon's first and only score of the first half. It gave them a 7–0 lead, and they would take a 7–6 lead into halftime after the Duesler touchdown.

Perusek, who didn't play in the Eagle loss the prior year to the Shoremen, went for 85 yards on 18 carries and 2 touchdowns. Coach Kostelnik talks about why it was tough to stop Perusek: "The kid was very dynamic and could make you pay for mistakes. Any game against South is a game you have to be buttoned up and know that there are so many moments to make an impact. Perusek made the most of his in that opening week."

The Shoremen used two long field goals in the third and fourth quarters by Harry Hebert to lead late, 12–7. A clutch Avon drive, helped out by some costly penalties, allowed Nick Perusek to burst one through from 16 yards out with five minutes left to eventually win the game, 13–12.

The game saw 3 touchdowns, and only 1 converted extra point. It was a game of defense and penalties on both sides of the ball. Perhaps the schedule makers needed to consider moving this one later on the schedule; week one made both teams look rusty and not at their best.

At the time, this was just another version of the rivalry game. Little did I know that it would soon become "the rivalry" that would define Kee On

Sports for many years to come. Later that season, I began a podcast, *The Player Spotlight Series*, and we wound up having numerous players from each team on the show. It was during those episodes that the rivalry got taken to a new level and led to incredible drama as the year went on.

Over the next eleven weeks, Avon Lake went on to have an amazing run on both sides of the ball. While the offense put up points in bunches, the defense was lights-out and shut out six opponents in that span. Harry Hebert was switched to defense full-time because of injuries to players, including Sean Summers. This meant that Corbo took over at quarterback full-time as well. It all worked out for Avon Lake, and things seemed to be heading in their direction as the two teams got set to face off again in the regional championship game at North Ridgeville High School.

Coach Kostelnik touches on why they were able to go on such a run:

> *Seizing the moment. Like I said, you have so many moments to make an impact in the game, and you have to make the most of them. We had so many great players on that team, and each one of them were finding their way in those next eleven games. They took pride in what they were doing, and as a coach, that's all I can ask for. Coach Brickley and our staff did a great job prepping those defenses to be successful.*

Avon, on the other hand, while also winning their next eleven games, dealt with one injury after another to every key position on the roster. Among the casualties were starting quarterback Danny Zeh, starting all-state-caliber running back Nick Perusek and then backup quarterback Niko Pappas. The Eagles couldn't catch a break. But with the colorful play calling of Elder and the dynamic ability of do-it-all player Joey Lance, the team continued to find ways to win heading into the regional championship game on November 22, 2019.

The Shoremen had a perfect opportunity. One of the top defenses in the state, they were primed to go to the state finals for the first time since 2005. Authors of six shutouts that season, they felt they had the upper hand this time over their archrivals. But it was not meant to be.

The night belonged to both defenses. Avon showed theirs was every bit as good. Notwithstanding, Shoremen star running back Gage Duesler, who ran for 116 yards on 14 first-half carries, out-gained the entire Avon team. But the Eagle defense made the big stops when they had to.

The only Avon Lake points came on their first possession. After an Avon punt, the Shoremen went 47 yards, mostly on Duesler runs, and settled for a Harry Hebert 36-yard field goal.

Avon knotted the score after a flurry of punts by both teams when defensive back Mitchell Dupras intercepted a pass and set the Eagles up at the Avon Lake 38. The Eagles could get no closer than the Shoremen 15 and settled for a 31-yard field goal by Nathanial Vakos. With 2:30 left in the half, Avon Lake drove to the Avon 16, and the usually automatic Hebert missed a 33-yard attempt that gave Avon momentum going into the locker room tied at 3.

The second half was an example of what this game was: a matter of which defense cracked first. The two teams traded punts, and at the five-minute mark, Avon took over at their own 5. The team methodically moved downfield behind Joey Lance and Devon Hunter.

On a second and 4 from the Eagle's own 42, Lance optioned to the right, broke containment and scampered 58 yards with the go-ahead score just before the end of the third. Avon took a 10–3 lead into the final quarter.

That is when the Avon defense knew this one was theirs. After a three and out, they marched to the Avon Lake 9, where Vakos kicked a 25-yarder to extend the lead to 13–3. The backbreaker happened on the ensuing drive, when Mike Matlak picked off Michael Corbo and raced 67 yards untouched for the game's final score.

In a losing effort, Duesler racked up 137 yards on 18 carries, but only 21 in the second half. Corbo added 56 on the ground and 107 through the air. The biggest problem for the Shoremen not only this night but also in the first encounter against the Eagles was the amount of penalty yards; it became a larger stat than any other number put up that night.

After the game, Shoremen head coach Matt Kostelnik reiterated that in the two games against Avon, they had 250 yards in penalties. He stressed that you have no chance to beat a team of Avon's caliber giving them all those opportunities.

Hunter ground out 100 yards rushing for Avon on 25 tough carries, and Lance rushed for 120 yards on 15 carries. Avon quarterback Chase Myers, a sophomore, was limited and only attempted 5 passes, completing 2 for 21 yards.

Coach Kostelnik talks about the emotions of the night and what went wrong:

> We broke our record of penalties that we set in week one. We had 100-yard rusher in Duesler in the first half and that was virtually erased by 100+ yards in penalties.
>
> That night we never seemed to sustain momentum to finish a drive. It is a rare occasion that South is going to beat themselves, and in that game we

continued to take ourselves out of favorable situations to be successful, and their kids made plays in the moment. Both teams fought hard, and I am proud to have coached our boys in that game.

We all make mistakes in any given game, including coaching, but it is how you finish. I felt we laid it all out there that night, and I am proud of those kids. Mistakes are only mistakes as long as we learn from them.

The start of the 2020 season was perhaps the craziest in the history of the OHSAA, as the world struggled to cope with a pandemic. It was a wild opening night that saw the Avon Lake Shoremen looking for revenge from the previous year's regional playoff loss. COVID-19 had struck the previous March and put the entire 2020 season in jeopardy. In what seemed like daily press conferences with Governor Mike Dewine and months of waiting for an answer, football fans finally got it in late August. Would they get their beloved high school football back in time? Once Dewine let it be known that high school football would in fact take place, this game instantly became the one on everyone's mind.

As painful as the wait was to find out if these teams would get a chance to install another edition into the rivalry, it was made even more painful, as opening night was accompanied by thunderstorms. The storms were so bad that games all over Northeast Ohio were canceled and soggy fans were sent home from Avon Lake Memorial Stadium. Well, I should say it sent parents home. No fans were initially allowed in during the COVID era, only parents.

Yes, that's right, the game everyone wanted to see would have to wait twenty-four more hours and led to a once-in-a-lifetime "Saturday Night Clash" between the two bitter rivals. What wound up happening furthered the legacy of this great rivalry and made Avon Lake fans, players and coaches start to wonder if they were snakebit.

Coach Kostlenik explains how his team handled the delay: "We have a routine whenever we have these types of odd days to prepare for. I think that showed on how fast we came out in the first half. As I tell the kids, control the controllable. There was a lot of things out of our control, but the boys handled it well."

In the first quarter, the Avon Lake Shoremen came out firing on all cylinders. Running plays from Mike Corbo and new starting running back Mason Wheeler set the tone for the game early on. The drive included a 62-yard scramble from Corbo, and it was capped off with a Wheeler 8-yard touchdown run. Wheeler was set to get the bulk of the carries that night, as his fellow backfield starter Gage Duesler was out of the lineup.

Up 7–0, the Shoremen punt returner Jared Krakowski rumbled for a 61-yard touchdown, and just like that, it was 14–0 and all Shoremen only a few minutes into the game. On the next possession, Avon's senior quarterback, Niko Pappas, led the Eagles to a touchdown with his legs and his arm. Great passes to Mike Matlack and a 27-yard touchdown catch from Michael Ptacek put the Eagles on the scoreboard for the first time that night. It cut the lead in half and gave the Eagles a chance to stay in it.

On the very next possession, the Shoremen answered with another touchdown when their offensive line created huge holes. Talented running back Mason Wheeler read the holes beautifully and started producing huge plays. The drive was capped by a Wheeler 2-yard touchdown run as it appeared nothing could stop Wheeler and the Shoremen.

Another drive from the Shoremen late in the first half failed to produce a touchdown, but they salvaged a field goal from Owen Wiley with just three seconds left in the half, taking a 24–7 lead into the locker room. Corbo and Wheeler each had over 100 rushing yards in the half.

Surely, nothing could stop Avon Lake this year. It was a sure thing to be up big, 24–7, and running all over the Eagle defense. But that is when fate stepped in and changed everything. Wheeler had to be raced to the hospital at halftime with dehydration issues. Without Duesler, the Shoremen were suddenly playing to survive instead of playing to dominate, as they had been in the first half. Still up 24–7 with that incredible Shoremen defense, they simply needed to hang on. It seemed more than plausible that they would. But they didn't.

In the third quarter, a couple of stalled drives by both teams seemed to favor Avon Lake, who was sitting on a big lead. The Eagles and Pappas kept plugging away and never seemed to panic, knowing they had time and believing in their athletic talent. This led to a 24-yard field goal with 3:04 left in the third quarter by sure-footed Nathanial Vakos. The Shoremen lead was now 24–10.

Avon's Niko Pappas used his athletic skills with his arm and his ability to scramble and create big plays in the fourth quarter. Even with a tipped-ball interception of Pappas by Shoremen cornerback Mitchell Fedders in the middle of the fourth quarter, the Eagles believed in their talent and never wavered.

There were no worries as Pappas took over the fourth quarter with big plays, capped off by a 30-yard touchdown pass to senior wide receiver Mike Matlack, who was starting to make a huge difference for the Eagles. With 5:07 left in the game, the Shoremen lead was now down to 24–17.

With costly penalties and mistakes late in the fourth quarter, the Shoremen were forced to punt from their own end zone. Despite a very favorable bounce on the punt, the Eagles had the ball on the home team's 40-yard line, and momentum seemed to be with them.

With just over three minutes left in the game, the Eagles pulled off their first trick play of the game. A reverse to Mike Matlack surprised the Shoremen and netted a 15-yard gain. The momentum was now with Pappas. He took a sweep left into the end zone with just 1:39 left in the game, which was now tied at 24 apiece.

As remarkable as the comeback was, the Shoremen still had a chance to win it in regulation. Avon Lake was sparked with a great catch for 43 yards by Jared Krukowski. Then a scrambling Corbo threw a bullet on the run to Sam Mikolich on the sidelines as he got both feet in for the catch.

This set up a field-goal try with just two seconds left on the clock as the Shoremen turned to their All Kee Sports kicker Owen Wiley. He almost never missed, and a 30-yarder was typically a sure thing for the young man. Except this time. Wiley's attempt from 30 yards bounced off the left upright after a bad snap caused a slight hiccup in his motion. The game was headed to overtime tied at 24–24

In the first overtime, both teams appeared to be playing it safe, and both Vakos of Avon and Wiley of Avon Lake were able to convert field goals. The score was now 27–27. The Shoremen would be starting the second overtime on offense. A few penalties backed the Shoremen up before a 39-yard field goal by Owen Wiley put Avon Lake up, 30–27. Wiley had rebounded from the fourth-quarter miss to make two clutch overtime kicks. He gave the Shoremen a shot to win—as long as the defense could get a stop. They couldn't.

Niko Pappas, after two plays of no yardage, threw a sharp pass on third down over the middle to Kam Erskine for the 20-yard overtime touchdown and victory. Pappas would use this one game to propel him on to an amazing season for the Eagles. He put up remarkable numbers and made one fourth-quarter comeback after another before it was over. On this night, the Eagle bench erupted with euphoria. They had pulled off a stunning comeback.

The home-team Shoremen were stunned and disappointed. They had given everything they had on the field on this opening night. Still, they walked away with a 33–30 overtime loss to crosstown rival Avon in an epic battle. Some losses sting more than others, and this one did for obvious reasons.

Coach Kostelnik reflects on everything about that wild opening night:

Mason Wheeler was on a tear that night, and unfortunately suffering that injury in the second half really hurt our ability to be dynamic on offense in the second half. He was waiting for that moment, and he shined.

It was so great to see Michael Corbo step up at the end of the game and lead what could have been a game-winning drive. It was disappointing to watch it slip away from him. I think what we saw was his ability to get the job done in a pressure situation.

We lost the ability to be dynamic on offense. Our third running back, Sean Summers, was really running hard, but playing both ways took its toll. Sean is the type of kid you dream of as a coach, but he was clearly gassed. We were scrambling to find someone, even running DePaul, who had not taken a carry in the game. We are blessed at Avon Lake with fine young men, and they proved they wouldn't quit that night.

In Owen Wiley's defense, the snap at the end of regulation had been rolled back to the holder, throwing off his timing. Our starting long snapper was out that night as well. We knew we had something special in Owen and our other players when they refocused to hit the overtime field goals. That same snapper stepped in for Owen later on in the year in a crucial situation to seal a game.

Our strategy on defense in that second overtime was to keep the ball in front of us and get after the quarterback. A split-second later, and we get a sack as their quarterback was knocked to the ground. Plain and simple, they made a great call, got the matchup they wanted and executed. Hats off to them. My boys played hard and just came up short.

But fate is a crazy thing, and both teams went on massive winning streaks yet again until they faced each other in the regional championship for the second straight year. This time, both teams were healthy. It would be the very best versus the very best. Because of COVID, the neutral sites were done away with. This game would take place at Avon on November 6, 2020.

With four seconds on the clock and the game knotted up at 17, junior sensation Nathanial Vakos blasted one though from 30 yards that would have been good from 45 and advanced the Avon Eagles into the state semifinals against Hoban. It was another dramatic clash of Avon against Avon Lake and another walkoff winner for the Eagles to end the Shoremen's season for the second straight year.

After a promising opening drive by the Avon Lake Shoremen was cut short due to penalties and a botched snap, they were forced to punt. The Eagles

The coin toss at the regional championship game between bitter rivals Avon and Avon Lake. *Author photo.*

wasted no time responding, and it was Niko Pappas finding the suddenly red-hot Tim Conwell from 81 yards out to draw first blood in dramatic fashion. It was far from the only drama the night would bring.

The Shoremen drove the next time they had the ball, and it looked promising. This time, it was a Michael Corbo fumble that gave the ball back to the Eagles and cost the Shoremen a chance at scoring. I'll say this: the officials made some bad calls that went against both teams. This time, it went against the Shoremen. I was looking directly at that play, and the fumble was caused by the ground.

Ironically, it was another interesting call that would help the Shoremen at the goal line a few minutes later, when they got the ball back. Still down 7–0, they went for it on fourth and 1 from the Eagle 2-yard line. Corbo snuck it with a great push from Griffin Lidyard and appeared to get in. However, as he was reaching over, the ball was swatted away.

The refs could have called it either way but awarded Corbo and the Shoremen the touchdown, making it 7–7. Had they given it to the Eagles, it would have been a fumble in the end zone, resulting in a touchback. They didn't, and it was tied halfway through the first quarter.

After touchdown runs by Gage Duesler and Niko Pappas made it 14–14 with six minutes left in the first half, it looked as though it would be a shootout. It was then that both defenses stepped up and started locking down

the opposition. Pappas was a magician on his run, faking out everyone on the field and half the people in the crowd. Duesler just steamrolled through on his and wouldn't be denied.

Both teams would pick off the opposing quarterback before the half was over. Corbo was picked off on a third and 2 trying to throw downfield, and Pappas was picked off by Sean Summers at the goal line with eighteen seconds to go. The first half ended tied at 14.

The third quarter flew by with little progress on the scoreboard. In fact, neither team scored. The Eagles appeared to have a great drive going, but it was slowed and then ended on back-to-back stops by Nathan Schillinger of Avon Lake. Schillinger spent a lot of time in the Eagle backfield that evening and had one of the best games I have ever seen him play.

As I predicted in my pregame article, the game would come down to the kickers. Vakos made a field goal from 27 yards out to make it 17–14 Eagles with 9:55 to go. Owen Wiley answered with a 27-yarder of his own with 5:40 remaining.

It was on that Shoremen drive that a potential touchdown catch in the corner of the end zone by Jared Krukowski was mistakenly called incomplete. We may never know what really happened, as several angles show his foot being in. But if the referee's reason for the call was that he didn't have control of the ball as he was coming down, that was the correct call. However, a look at the footage shows that it was a catch through and through.

I will make this as clear as I can: his foot was in, and I don't think anyone is disputing that. My educated guess is that the official believed he didn't have possession of the ball. If the ref was saying otherwise and that his foot wasn't in, then he blew the call. It's just that simple. His feet were in.

Would that same official make that call again? Who knows? And you hate to see a game this big have a play like that occur. But that is sports as we know it. Sometimes you get the breaks, and sometimes you don't.

The play wound up all over social media and was shown from several different angles. I watched it again a few years later, and there is no denying that it was a catch. Perhaps the funniest part of the video is a random kid standing there by the pylon, screaming at the referee, "You stink!" Despite all that, the Shoremen still had a chance to tie the game, and they did so with 5:40 left.

Coach Kostelnik reflects on that moment:

This was one of those moments that I felt for the kids and especially Corbo. He had only lost to one team as a quarterback, and here he was again

leading a drive to put us in a situation to be successful, and something happened that was out of our control. Sure, it was a bad call, but the kickoff after that field goal decided the game by field position. Both teams had enough time and time outs to make a run, and ultimately they finished and we didn't.

Controversial plays aside, both teams had chances to win the game late. Avon had a remarkable kickoff return to set up shop on the Shoremen 33-yard line. They instantly shot themselves in the foot with a clipping call on Jake Frye that resulted in a personal foul and Griffin Lidyard on the turf.

I'm happy to report that the big man got up and returned to the game. The next two plays resulted in back-to-back sacks by Jacob Sintic and Lewis Miller that ultimately resulted in an Eagle punt.

The Shoremen started their drive with 3:11 left on their own 19-yard line but only went backward and eventually had to punt. The Eagles took over at the Shoremen 42 with 1:28 to go and worked themselves into field-goal range for Vakos to seal the deal.

Niko Pappas once again did it all for the Eagles behind center and in their secondary. The young man is a champion and a leader. Pappas would finish with 209 yards passing with 1 touchdown and 1 interception. He also ran for a touchdown and 112 yards on 15 carries. For the second straight week, his main target was Tim Conwell, who pulled in 4 catches for 107 yards and the game's first score from 81 yards out.

I should point out as well that Andrew Smith, who is a great run-blocking tight end, also has a great set of hands. He hauled in a 38-yard pass from Pappas.

Gage Duesler of Avon Lake had a huge first half with 92 yards on 11 carries and 1 touchdown. Coach Elder made the adjustment and held Duesler to 11 yards in the second half on only 5 carries. Corbo finished with 53 yards rushing on 13 carries with 1 touchdown. He threw for 123 yards on 6 of 14 passing as well.

Coach Kostelnik reflects on the emotion he had for his seniors that night following the loss: "They are a special group of players, as ten of them would go on to play college football. They had an incredible work ethic and fantastic leadership. I am excited to see all of their next steps in life, and hopefully I had a positive impact on getting them there."

As for me, looking back at it now, a little over a year later, I can honestly admit I think about that game once a day. It was nearly sixty-five degrees in late fall, just beautiful out. As crazy as 2020 was, that may have been

the craziest part. But at the same time, everything was pushed up several weeks with only a six-week regular season. It was the only game I've ever covered from outside of a press box, actually sitting at a table they put in the stands. The press box was maxed out because so many outlets were there and because of COVID restrictions.

I remember hugging Avon Lake players after the game and wishing the seniors the best of luck as they cried their eyes out with the realization that that was it for them. Both teams had such special groups of young men. Many of them were on my show that season. In fact, more than fifty players from both schools appeared on the podcast. My heart went out to Avon Lake in the loss. At the same time, I was proud of the Avon kids. It's tough being a reporter with a heart. Games like that bring out all of the emotions.

I think a lot of fans snuck in after kickoff somehow, because by the time the second half started, the place was packed and very loud. The game was being played under COVID rules, and the stadium wasn't supposed to have more than 25 percent capacity, but it sure seemed packed. Or maybe it was just the parents screaming their heads off (more than likely the case). But I like to imagine it was packed.

I'll say it again: great kids, great parents, great coaches, great schools! That school and that entire season will live in our memories forever. The win sent Avon to play Hoban yet again for a trip to state, but we will cover those battles later in the book.

The 2021 edition was moved back to week four of the season. Coach Kostlenik of Avon Lake was happy to see the game moved to a later date in the season.

> *I have so much respect for Coach Elder and the South program, but he and I disagree on this point that it is nice to have the game later in the season. In fact, in 2023, the game will be week ten, which I am really excited for. I know it will present new challenges, like how physical the game is and turning around getting ready for playoffs, but Coach Elder and I both will get our kids ready to the best of our abilities.*

Avon Lake had to deal with a week of drama, as their normal starting quarterback, Jeremy Dzik, was out, and they had to go with Jake DePaul. Kostlelnik explains: "The COVID bug finally came to Avon Lake after twelve games of little to no interference. There is not much to say about DePaul other than he is a great kid who knows how to be a gamer. We stressed nothing to lose and everything to gain, and he delivered."

The Eagles struck quickly with a three-play drive that ended in a 35-yard touchdown run by Jakorian Caffey to being the 2021 edition of the Silver Rail Rivalry. A few possessions later, the Eagles extended their lead with a 50-yard field goal from Nathaniel Vakos. It appeared that the Eagles were well on their way to another big home win, but everything fell apart in the second quarter. (Portions of this game recap are from Dom Clary of Kee On Sports.)

For Avon Lake, the second quarter began with a 46-yard touchdown pass to Matthew Stuewe. The point after was missed, however, leaving the score 10–6. A few minutes later, it was Avon Lake with the ball back and kicking a Wiley 45-yard field goal to close the gap to 1 point. Avon Lake was just getting started, as they would score 21 more points before the quarter was over to take a 30–10 lead at halftime.

A Jake DePaul quarterback sneak gave the Shoremen their first lead. Then a Nathanial Vakos punt was blocked. Pierden Pepe recovered the ball at the 5-yard line and scored. Avon Lake wasn't done yet. DePaul launched another touchdown pass to Stuewe, who finished the half with 110 yards, 2 touchdowns and 5 receptions. He wouldn't be targeted the rest of the game.

Coach Kostelnik had this to say about the big quarter for his team:

The boys stepped up and made plays with turnovers and big third-down wins that put us in the best position to finish the game. We also were able to capitalize on their mistakes.

I think without a doubt the factor that decided that game was the turnovers in the first half. Without those we do not have the lead that we did going into the second half. The boys played physical and were able to dig in the second half, and I couldn't be happier than that.

The Eagles came out of the locker room motivated. They stopped the Shoremen and scored a quick 7 points. Sam DeTillio found Caffey underneath, and he went untouched for the 6-yard score.

Caffey scored another touchdown as a receiver with about seven minutes left in the game to make it 30–24, but the Eagles couldn't get any closer in this one.

Avon had one last chance to take the lead with about four minutes left. Avon drove down the field with a mix of passes and runs to get close to the Shoremen 30-yard line. As Sam Detillo handed off to Caffey, the ball hit the ground, and a pile of Shoremen jumped on it with just two minutes remaining.

NORTHEAST OHIO HIGH SCHOOL FOOTBALL RIVALRIES

Avon Lake ran the ball right through the heart of the Eagles and killed the clock. DePaul took a knee in victory formation, and the Avon Lake students rushed the field to celebrate a win over Avon for the first time since 2018. Avon fought hard to get back into the game, but their efforts were too little, too late.

The loss by 6 points took the Eagles to 2-2 on the season and 0-1 in the SWC. Caffey was the main bright spot for the team, finishing with 187 total yards and 3 touchdowns. Avon Lake's strong second quarter and tough defense were enough to hold the Eagles, and they moved to 4-0 on the year.

Jake DePaul, the surprise signal caller for the Shoremen, was the Player of the Game. He was able to get past the Eagle defense on his feet and with his arm. He eclipsed 200 total yards while scoring 3 touchdowns.

It is interesting that the Avon Eagles lost the game, as they had in 2018, and then went on a massive winning streak that took them to the state semifinal game against Hoban. We will get to that rivalry in a bit. The Eagles wouldn't lose again, winning their next 9 games before the Hoban clash. Their only losses that season came to Drew Allar and Medina, their rivals, and then to Hoban. Not too shabby.

As for the Eagles, nothing went right again in a bizarre turn of events. The Shoremen were ravaged by injuries and ended up losing 4 of their next 7 games, including getting knocked out of the playoffs in the first round at home to St. John Jesuit, 34–13.

All of this just goes to show that when it comes to the Silver Rail Rivalry, you never know what to expect. Since 2015, the teams have met in the playoffs three times and have had 6 games go down to the last possession. I don't know about you, but I find it impossible not to get roped into this amazing rivalry. Let's see what the fall of 2022 brings us.

Coach Kostelnik has these final thoughts on the rivalry:

> *The mutual respect that each city has for the other and how we channel sports into concept. We have so many teachers, former players' kids and community members that work so closely with the other city. Then you add the cliché of being separated by railroad tracks, that makes a perfect recipe for an incredible rivalry.*
>
> *The superintendant for South lives in Avon Lake, which even more adds to the fun tensions that each athletic event brings. It also helps that both schools have had both successful athletics and academics. With all of this I still go back to the mutual respect that we have for each other.*

Coach Elder has been great to me, having a shared history at Mount Union, and even my community members are shocked when I say he is a great guy to grab a beer with and shoot the breeze. Sure, do we want to fight each other on a Friday night during the game? Of course. But, before the game and after the game, we always come together with a sense of pride for our boys and gratefulness that we get to experience this wonderful rivalry.

It was Coach Elder who gave me the advice before the game this year, to enjoy the ride, because at the end of the day, this opportunity to compete in the way we do is few and far between.

INSTANT CLASSICS

Massillon vs. Hoban

I t is funny how things tend to work out. Sometimes, you have rivalries born out of physical proximity. Other times, a rivalry develops over many years of playing in the same conference and facing each other year in and year out. In this case, it happened organically over the course of three seasons, as the schools hooked up in one big game after another in the postseason.

While Tiger fans dreamt of winning OHSAA state championships in tournament play, Archbishop Hoban Knight fans actually got to cheer their team winning championships three years in a row headed into the 2018 season. The hype always seemed to be around Massillon, while the substance and championship gold was located in Akron with Hoban year in and year out.

Coming into 2018, if the Tigers were finally going to capture their first traditional state championship in playoff tournament form, they were going to have to defeat the hottest high school football team not in only Ohio but also in the country.

The Knights came into the 2018 OHSAA Division II state title game at 14-0 with only one close game all year. That contest came opening weekend against St. Ignatius, a 21–14 victory for the Knights. For the next thirteen weeks, the Knights were on cruise control. Their next-closest game was a 47–28 drubbing of Wayne. And let me tell you, it wasn't nearly as close as the final score indicated.

Through the 13 games following the matchup with St. Ignatius, Hoban's average margin of victory was 37.8 points. They were fresh off a 42–7

blowout of Avon, a game we will discuss at length later on. They were led by two great running backs in Tyris Dickerson and Deamonte Trayanum. That combination, along with sophomore quarterback Shane Hamm, seemed unstoppable.

The Knights were 14-0 in 2018 and the winners of three straight state championships. In that stretch, they compiled a record of 14-1 in 2015, 14-1 in 2016 and 14-1 in 2017. Add the four remarkable seasons together, and their overall record was 56-3, the only losses coming to state powerhouses St. Ignatius in 2017, St. Edward in 2016 and Benedictine in 2015. The run defined dominance!

Massillon was no slouch coming into this one, also 14-0 and fresh off one of the most impressive seasons in Ohio high school football history. Here are some of the scores from their 2018 campaign.

35–7 over Saint Vincent–Saint Mary
49–0 over GlenOak
51–21 over Warren G. Harding
49–7 over Montclair
42–0 over Firestone
42–14 over Austintown Fitch
101–6 over Sun Valley
41–0 over Louisville

Over the course of fourteen weeks, their average margin of victory was 32.8 points per game. The game was seen as the "Super Bowl" of Ohio high school football. They were considered the best two teams not only in the state but also in the nation. Fresh off a 41–20 state final four victory over perianal championship favorite Winton Woods, the Tigers were ready for the epic clash.

Their fans were ready as well, as were assorted media members, Hoban fans and others trying to find a place to park anywhere near the stadium. The streets overflowed with Massillon Tiger fans. Everywhere you looked was orange and black. I cannot begin to tell you how many license plates I saw with a picture of Obie, the beloved Massillon mascot.

Starting in 1970, the Massillon Tigers began the tradition of having a caged tiger appear at halftime of their games. It was a great tradition that fans loved and became a staple of Massillon home games. Sadly, like many other things in life, once "cancel culture" became a nuisance in 2020, the school had to retire the fifty-year-old tradition under pressure from a

loud group of people who had their underwear on too tight and needed something to complain about.

As I said, it was orange and black as far as the eye could see, and the twenty-one-thousand-seat Tom Benson Hall of Fame Stadium in Canton was filled with Tiger fans well over two hours before the game began. The Hoban Knight fan base was extremely respectable as well, but it was clear where a large portion of the fans stood.

I couldn't sleep the night before this game. I was too excited to catch a wink. I had zero emotional ties to either school and stood to gain nothing from either side winning. But it didn't matter. I had never seen Massillon play in person as a reporter, only as a little kid. As for Hoban, I had seen them trounce Avon in back-to-back state final four games and knew firsthand just how good they were. I wanted to see what would happen when the team I had seen (Hoban) played the team everyone was talking about (Massillon).

It was billed as the "High School Game of the Century" for many reasons, and it didn't disappoint. The four quarters of action on Thursday night, November 29, 2018, would go down as the most dramatic I'd ever seen at the high school level. The hype was warranted, and the classic took place!

The Archbishop Hoban Knights survived a wild second-half Massillon comeback to capture the Division 2 state title game in Canton. It was a hard-fought game filled with emotion, as the Knights took down the Tigers, 42–28, in front of a packed house at Tom Benson Stadium to secure their fourth consecutive state championship for Head Coach Tim Tyrell and their second straight in Division 2.

The Archbishop Hoban Knights were once again an offensive machine in every facet they needed to be. Quarterback Shane Hamm led the way, passing for 118 yards and 2 touchdowns. He also ran for 66 yards and 2 more touchdowns. Hamm was everywhere and, for a sophomore, showed the poise of a senior.

Helping Hamm was his two-man wrecking crew in the backfield, Tyris Dickerson and Deamonte Trayanum. The senior Dickerson had a monster night himself, finishing with 211 yards on 28 carries, scoring 1 touchdown on the ground and 1 in the air.

Trayanum was every bit as dangerous, as the junior rushed for 82 yards on 17 carries. He scored his lone touchdown on the ground, and it was the game-clincher. Trayanum was one of the best players in the state, and the entire country started paying attention to his senior season the following year. He wound up going to Arizona State to play running back for the Sun Devils and head coach Herm Edwards in his freshman and sophomore

years. After two years, one being a COVID season, he transferred to Ohio State his junior year to play linebacker.

It was well noted that the Tigers were without their star running back, Jamir Thomas, due to an injured ankle, but they did their best to move the ball on the ground when they needed to. Zion Phifer got the bulk of the workload, toting the ball 21 times for 82 yards and 2 touchdowns.

Little used that season, Kyshad Mack also stepped up in the moment for the Tigers, finishing with 69 yards on 6 carries with 1 touchdown. One only wonders how different the game might have been with a healthy Thomas.

The Knights opened the game on their own 21 after forcing a crucial turnover on downs after a 60-yard drive by the Tigers stalled out. The Knights wasted no time, pounding the ball with ease, and they proceeded to march 79 yards on six plays to score. All six plays came on the ground, courtesy of Dickerson and Hamm. They did it while taking just 2:55 off the clock.

Following a three and out, it was the Knights' turn to go back to work, and they sure did! It was an impressive two-play, 69-yard drive that took all of twenty-two seconds off the clock. This time, it was a beautiful 46-yard pitch-and-catch from Hamm to Mason Tipton. Seconds later, Hamm took it the rest of the way on a designed quarterback sneak with an empty backfield. Hamm raced by diving Tigers on his way to pay dirt to increase the lead to 13–0. The first quarter ended with the same score.

After another Tiger three and out, the Knights took over at the Massillon 39-yard line with a short field to work with. They were forced to a fourth and short after three solid stops by the Tigers. The Knights decided to go for it instead of kicking the long field goal. The gamble paid off, as Trayanum rumbled forward for an 11-yard pickup to move the chains. A few plays later, it was Hamm making it 20–0 with a goal-line sneak.

Just when it looked like it couldn't get worse for Massillon, it did. Devin Hightower picked off Aiden Longwell and took it back to the Tiger 35-yard line. One play later, Hamm hit a tightly covered Dickerson in the corner of the end zone to put the game seemingly out of reach. With ten minutes still to play in the second quarter, it was 27–0 Hoban.

Frozen Massillon fans were stunned but not totally quiet. They continued to scream and holler in hopes of doing anything they could to inspire their Tigers into making a comeback. For a brief spell, it seemed as though the raucous crowd made an impact. The Tigers found their first spark of the game.

Longwell took matters into his own hands by launching a 42-yard bomb to Jayden Ballard. The next pass was for 22 yards to Aydrik Ford to put them

in scoring position. Phifer would finish it off and get the Tigers on the board with a 1-yard touchdown run.

The excitement for the Tiger faithful was short-lived. The Knights were unfazed and took their time but were once again effective in scoring. This time, it was a ten-plus-play drive, milking the clock down to fifty-five seconds left in the first half before the red-hot Hamm hit Alabama commit tight end Caden Clark for a 28-yard touchdown to end all doubt—34–7 at halftime. The "Game of the Century" was a blowout as the teams headed to halftime.

Massillon was determined to go down swinging and went for the onside kick to start the second half. They recovered it and began to mount a rally. Longwell connected with Tre'Von Morgan for 25 yards. All of sudden, the Tigers were on the prowl. A few plays later, it was Phifer cutting into the lead with a 6-yard touchdown jaunt. An extra point later, it was 34–14, and the Tigers had life.

The Tigers then forced a rare Knight punt and continued the comeback. Longwell used his legs and arm to get the Tigers down to the Knight 11-yard line. He was assisted by a couple of long Mack runs. In the blink of an eye, we suddenly had a game, as Mack dove in over the plunging Knight defense, scoring and cutting it to 34–21 with fifty-six ticks of the clock remaining in the third quarter.

The Tigers kept the momentum squarely on their side by forcing another Knight turnover on downs. They took the ball over and wasted no time. Longwell connected on a 67-yard launch to Ford for a score. The fans went into a frenzy. Suddenly, it was a 34–28 game with 9:13 remaining. The hype was real!

It appeared that the miracle comeback might actually happen when the Knights were forced to punt yet again at the 6:23 mark of the fourth quarter. However, this time, Coach Tyrell called for a fake, and they converted it. It was a brilliant and calculated risk from Tyrell that would eventually save them the state championship.

A few minutes later, the Knights officially ended all doubt with a clinching Trayanum 2-yard touchdown. They converted the 2-point conversion and extended the lead to 42–28. The game concluded by the same score. Few games live up to the hype that this one had coming into it. This game absolutely did and will be seen as an instant classic.

Fifty weeks later, the two teams hooked up at Akron InfoCision Stadium on Friday night, November 23, 2019. Hoban was playing through multiple injuries, and the Massillon Tigers were out for blood and revenge. They

didn't want to hear any excuses. They had one mission: to avenge the prior year's loss.

It was mission accomplished, as the Tigers defeated Hoban, 17–14, to run their record to 13-0 and advance to the state final four. The Tigers snapped the Knights' incredible 22-game playoff winning streak, which included four consecutive state championships (two in Division 3 and two in Division 2).

Both teams took a while to get going, but the Tigers struck first after Aidan Longwell hit Andrew Wilson-Lamp for a 53-yard touchdown pass to give them a 7–0 lead. If the Tigers thought they were going to roll from there, they were wrong. Hoban responded quickly. Shane Hamm found Brayden Fox for a 40-yard touchdown reception to tie the game.

After recovering from his second interception of the quarter, Longwell slung another touchdown pass. This time, he connected with Zion Phifer for a 9-yard score to give the Tigers a 14–7 lead at the end of the first quarter.

From the looks of it, many observers thought we were in store for a high-scoring affair, but we were mistaken. Hoban's Victor Dawson tied the game at 14–14 after a 4-yard rushing touchdown. Then, just before halftime, Alex Bauer of Massillon gave the Tigers a 17–14 lead. Fans didn't know it at the time, but that field goal would end up being the final points of the game.

Depending on how you look at it, one could say the second half was dominated by the defenses, but I would argue that the second half was one of missed opportunities, the biggest coming on the Knight's side. A fumble at their own 41-yard line with around 7:30 left in the game was the first huge missed opportunity, but the last was the most egregious.

After Hoban elected to bypass a field-goal attempt to tie the game, quarterback Shane Hamm was sacked on fourth and 6 with 2:05 remaining in the game. Massillon was able to pick up one more first down, take a few knees and slam the door on Hoban's attempt at a fifth straight state championship.

As great as the win felt for Massillon and their fan base, they met with the same fate yet again in a state title game. In fact, a few years later, David Lee Morgan wrote a story about the 2019 Massillon Tigers that I found to be perplexing, considering they had yet again fallen short of the title. It's not often that you see a book written about a second-place team, but that is the unrelenting Tiger Pride.

This most recent loss (at the time) in the state championship game was against the two-loss Cincinnati La Salle Lancers. At 14-0, the Tigers came in heavily favored not only in their minds, but also on paper. It wouldn't matter, as the Lancers controlled the game from start to finish.

In a battle for the Division 2 state championship, it was the La Salle Lancers running away with a 34–17 victory over Massillon. The Tigers were unable to stop the run or hold on to the ball, and it cost them big. The Lancers made it look easy at times.

The Lancers shut out the high-powered Tiger attack in the second half and made what had appeared to be a close game a blowout. The Lancers were the definition of a team, excelling in all three phases of the game: ball-control scoring on offense; creating turnovers and making adjustments on defense; and a tremendous field-goal kicker to ice it late.

The Lancers used a form of the wildcat offense with their two terrific rushers, GiBran Payne and Cam Porter, along with their extremely mobile quarterback, Zach Branam, to run at will all game long.

Porter finished with 57 yards and 3 touchdowns on 28 carries. His backfield mate Payne tallied 133 yards on 15 carries with a score. Branam finished with 166 yards on 22 yards, along with several key big plays to keep drives alive.

Their defense held the Tiger high-profile scoring attack to only 10 first downs and forced 3 fumbles. The victory could have been even bigger for the Lancers had it not been for six crucial penalties costing them 61 yards.

The biggest difference was the running game—one team had one, and the other team struggled all night. The Lancers finished with a combined 337 yards on the ground, and their defense held the Tigers to just 82 yards.

The lone bright spot for Massillon was their ability to throw the deep ball. It kept them in the game, and it appeared for a moment that it might be enough to regain them the lead in the third quarter.

Longwell went 12 of 23 for 245 yards. His strong arm looked impressive at times, but he did miss several wide-open receivers a few times. All in all, Longwell had an outstanding season despite that night's outcome.

His biggest and best target was Andrew Wilson-Lamp, who got open several times. Wilson-Lamp went off for 128 yards and 1 touchdown. And Jayden Ballard had a good night, with 88 yards on 7 catches.

The Lancers would go three and out on their opening drive, giving the ball to a Tiger team ready to roar. Longwell hit a 59-yard bomb to Andrew Wilson-Lamp on their second play from scrimmage to set up a first and goal from the 9.

They attempted two straight runs and then a post route to Ballard, but they couldn't get closer, and the Tigers had to settle for a field goal. It was Alex Hauer putting it through from 23 yards out to give the Tigers a 3–0 early lead with 8:39 to go in the first.

It didn't take the Lancers long to respond, as they looked furious on their following drive. They ran the ball down the field with no problems, using running back Cam Porter and quarterback Zach Branam. Runs of 20- and 30-plus yards put them inside the 8 for first and goal.

Porter is lightning quick, and this Northwestern commit may be playing on Sundays one day. His running mate GiBrian Payne is every bit as deadly. He proved this on his 5-yard touchdown score. He crossed the goal line as he fumbled, but after further review, it was called a touchdown. Just like that, it was 7–3. The Tiger fans booed heavily, but it didn't change the result. It was still a touchdown.

The Tigers started their first drive of the second quarter at their own 2-yard line and saw Zion Phifer gain 19 yards on the first play to get them out of that hole. However, on the very next play, it was Terrence Keyes getting stripped and fumbling the ball, allowing the Lancers to set up shop on the 17.

Zach Branam was an extremely patient runner behind his blockers. This young man is the real deal and can beat you a number of ways. A few plays later, it was Wildcat time, and the Tigers had no chance at stopping a charging Porter, who broke the plane to put the Lancers up, 14–3, with 10:34 left in the first half.

The Tigers were not fazed, however, and responded right back. This time, it was Longwell dropping a 38-yard dime to a wide-open Jayden Ballard to make it 14–10 and put Massillon back in the game. Longwell threw the ball like a frozen rope, right on the money. With 8:42 to play in the first half, this one had shootout written all over it.

It was yet another long drive almost all on the ground by the Lancers. Once again, it was Cam Porter getting them across the goal line with 6:04 to go in the half and giving the Lancers a 21–10 lead. Porter finished it, but it was a team effort, as the Lancer line dominated and runs by Brannam kept the Tigers honest.

Longwell hit Wilson-Lamp again, this time for 69 yards with 1:10 to go in the first half. No one was within 20 yards of the speed demon, and just like that, it was 21–17. The Tigers trailed but knew they would receive the ball to start the second half, and things were looking up.

The first half was a story of Massillon passing all over the Lancers, and La Salle running all over the Tigers. Need proof? Check out these numbers. Through two quarters, Aiden Longwell was 4 of 7 for 171 yards and 2 scores. For the Lancers, Brannam, Porter and Payne combined for 227 rushing yards on 29 carries for 3 scores. Those are video-game numbers, folks.

With all the momentum on their side, the Tigers failed to score on the opening drive of the second half. A promising Lancer drive was then shut down by a hurdling call on Porter, which in high school is a 15-yard personal foul. Yes, you read that right: "hurdling" is a thing.

The first play following the Lancer punt resulted in disaster for the Tigers. This time, it was Phifer fumbling. That was two very costly fumbles by the Tigers' two best rushers.

Once again, as in the first half, slow, methodical drives resulted in first downs. Using all three downs, chewing up clock and piling up yards put the Lancers back in the red zone.

Once they got their first and goal from the four, it was a jumbo set and Wildcat time, as Porter rumbled in to make it 28–17. It was Porter's third touchdown of the game. The Tigers didn't have an answer for the Wildcat jumbo.

With 9:30 left to play. Seibert hit a 43-yard field goal to stretch the Lancer lead to 31–17 and really place the Tigers behind the eight ball. Seibert put the final nail in the coffin when he bombed a 38-yarder with 2:26 to go. This kick put the Lancers up, 34–17, ending all doubt. It was another season in the books for the Tigers, capped off by another state championship game loss. It wouldn't be their last, however. Tiger fans still had plenty of heartbreak to endure.

In the spring, summer and fall of 2020, the only thing Ohio football fans wanted to talk about was, "Are we still getting high school football?" It seemed to be in constant doubt, but faith that the COVID-19 saga would simmer never disappeared, so the question became, "How do we make it work?" The OHSAA found a way, and most of the teams in Ohio decided to play, to everyone's delight.

For the most part, the concessions made seemed worth it. A ten-week regular season would now only be six weeks, and everyone would make the playoff tournament starting week seven. For one year, it was worth it to have high school football. Several schools chose not to play a schedule at all and simply sit things out.

This was before vaccines, and crowds were limited to parents of players only. Everyone had to wear masks. Coaches, refs, media members and players on the sidelines had to be six feet apart. Each team used their own footballs, and the referee wasn't supposed to touch it, even to spot the ball. A player had to bring it back to the line of scrimmage with him. Away schools' bands were prohibited from traveling, and locker room use was banned for most of the season as well.

Perhaps the biggest change benefited—or at least should have benefited—Massillon. The state championship games were moved from Tom Benson Hall of Fame Stadium and relocated to Fortress Obetz just outside of Columbus. It was a beautiful facility, but it sat only 6,500 people in bleacher-style seating. The Division 1 state championship game had been played there the previous week, and it appeared as if the games for Divisions 2 through 7 would be played there as well.

But as plans often do, these changed, to the extreme favor of the Massillon Tigers. Days before the Division 2 championship game was set to take place, Franklin County mandated a 9:00 p.m. curfew, which would make it impossible to get the game in. Athletic officials had to think quick. The only stadium big enough and available that quickly was Paul Brown Tiger Stadium—also known as the home of the Massillon Tigers. Go figure.

The home field advantage for Massillon seemed too good to be true. Arriving at the stadium, it was easy to see that more than just parents were in the crowd, and maybe one of every ten people had a mask on. The Tigers came into the game with a 10-1 record. They had lost opening week against St. Edward on a trick play at the end of the game and then rattled off 10 straight wins, including a 14–10 revenge win over La Salle the weekend before.

As for Hoban, it was business as usual. They came in at 10-0. They had five shutouts in those 10 games, including blowouts of St. Edward, SVSM, Kent, Mayfield, Benedictine and Hudson. They looked to be as unstoppable as ever, and with talents such as Kharion Davis, A.J. Kirk and now a senior in Shane Hamm, the Knights looked deadly.

Even with the sudden home field advantage in favor of Massillon, true talent took over, as it always does. Thanks to big nights from Kharion Davis, Shane Hamm and A.J. Kirk, the Hoban Knights secured their fifth state championship in six years. They defeated the Massillon Tigers, 35–6, to avenge their 17–14 defeat the previous year and once again hoist championship gold.

Shane Hamm was now part of three state championships in four years starting for Hoban. He had a big night. People might have questioned him due to his ankle issue, but he put those fears to rest quickly. Hamm finished the night with 172 yards passing on 9 of 10 attempts with 4 touchdowns. He also rushed for the game's first score.

Kharion Davis also had the game of his life. Davis, a lightning-quick and very special young man, went off for 2 touchdown receptions on 2 catches for 73 yards. He also threw a touchdown pass that was called back for holding.

He did it on defense as well, with a crucial interception in the Tiger red zone, as well as a strip and fumble recovery.

Tailback Victor Dawson was once again a force to be dealt with. He piled up 145 yards on 21 carries but didn't find the end zone. He didn't need to, as those 145 yards led to multiple touchdowns. Dawson is a special young man and an incredible talent.

The Hoban defense was once again a force and gave the Tiger offense fits all night. They held Tiger quarterback Zach Catrone to 7 of 18 passing, with 104 yards and 1 touchdown. He was sacked 5 times, as the Tiger line simply couldn't contain the nonstop pressure of the Knights.

They also did an outstanding job keeping Andrew Wilson-Lamp clamped down. Lamp had 0 catches and managed to pick up more penalty yards than anything else, including a crackback block that cost the Tigers a huge gain late in the third quarter when they were trying to mount a comeback. The West Virginia commit did have an amazing career as a Tiger and has a lot to be proud of. It was just one bad night.

The biggest story may have been the total yards in favor of Hoban. The team had 350 yards compared to the Tigers' 136. They also dominated the time of possession, with a whopping 29:44 to 18:16 advantage. Hoban overcame 8 penalties for 85 yards. The only down portion of this game was the countless personal fouls on both sides of the ball, something you hate to see in a championship game. But the teams' dislike of each other was clear.

The game started with back-to-back penalties, first a false start on Hoban, then a long pass interference called on Massillon. The next play was even crazier, as Victor Dawson raced down the sidelines for a 37-yard gain before fumbling out of bounds.

Moments later, the Knights were faced with a fourth and 1 from the Tiger 16. Coach Tim Tyrell pulled the trigger, and they went for it. The gamble paid off as Dawson took it for 11 more yards and the first down. Two plays later, Shane Hamm rumbled in under center to give the Knights a 7–0 lead. It was an eight-play, 72-yard drive for Hoban.

It looked like Dawson would break loose again to start Hoban's next drive after forcing a three and out by the Tigers. An Austin Brawley tackle saved what might have been a surefire touchdown run from about 60 yards out. A Shawn Parnell reception on the next play moved the ball to the Tiger 40 and put Hoban in Massillon territory again.

A couple of passes to Lamar Sterling moved the chains again, and Hoban inched closer to the red zone. From there, it was Sterling doing it again with his legs, using beautiful cutback runs to march the ball down to the Tiger 13.

Hoban Knight Shawn Purnell. *Julie Spisak Herzog.*

Your five-time state champion Hoban Knights. *Julie Spisak Herzog.*

The 2017 Hoban Knights. *Julie Spisak Herzog.*

It wouldn't be much longer until Shane Hamm threw a bullet to Kharion Davis on a slant from 11 yards out to extend the Hoban lead to 14–0 with eleven seconds left in the opening quarter.

It was a dominant quarter for Hoban that saw them control the ball for ten minutes. Dawson picked up 80 yards on 8 carries. Hamm went 4 of 4 for 48 yards and 1 touchdown. It was all Hoban.

The Massillon Tigers had a decent drive to start the second quarter, but it fizzled quickly thanks to one big stop after another from Michigan State commit A.J. Kirk of Hoban. Before the Tigers could start another drive, Austin Brawley picked off Hamm to put it to a halt at the Hoban 25. Brawley read Hamm's eyes perfectly and made a great read on the ball.

But it was all for not. On the very next play, the Knights picked off Tiger quarterback Zach Catrone. It was interception number 8 on the season for Kharion Davis, who continued to do it all. Hoban also struggled to convert, giving the ball back to Massillon near midfield after a punt.

The Tigers combined some nice plays by Martavien Johnson with a 15-yard penalty on Hoban to move the ball inside the Knight 25-yard line. Another personal foul on a sideline helmet-to-helmet hit moved the ball to the Hoban 13-yard line with forty-two seconds to go in the half.

Moments later, after the helmet-to-helmet hit, Zach Catrone bounced back and found Caiden Woullard over the middle for a 16-yard touchdown. Woullard caught it at the 4 and made a great second effort to break the plane with Hoban defenders draped on him.

However, another personal foul, this time on Massillon, made the extra point try a 35-yarder, which the Tigers promptly missed. Hoban took a 14–6 lead into the break. Massillon had just two penalties for 30 yards in the first half, but both cost them big.

The Tigers got the ball back to start the second half but couldn't do anything with it, punting back to Hoban. The Knights wasted no time, and Shane Hamm hit Kharion Davis on a 5-yard dump-off that Davis broke for a 62-yard touchdown streak down the sidelines. Just like that, with 8:48 to play in the third quarter, it was 21–6 Hoban. The quarter would end with that score.

Tim Tyrell went for it again on a fourth and 7 from the Massillon 36-yard line to start the fourth quarter. Tyson Grimm made that gamble pay off instantly, getting behind the Tiger secondary as they handled the blitz. Grimm was wide open to catch the over-the-shoulder toss from Shane Hamm straight into the end zone to put the game on ice. It was now 28–6 with 9:43 left.

Still up 28–6 with less than four minutes to go, it appeared that Hoban would run out the clock, but things got real chippie real fast, and Hoban went for more points. Hamm checked back into the game and promptly threw a touchdown pass to Chances Carter Hill from 12 yards out to extend the lead to 35–6. The play was followed up with ejections and personal fouls. Massillon wouldn't stop chirping, so Hoban made them pay yet again.

In the end, the crazy 2020 season ended with a dud, as the "Trilogy Fight," or the "Rubber Match," was a TKO. Hoban had no issues putting the Tigers away in front of their home fans. The great thing about this rivalry is that even with it being in its earliest days and with no guarantee of the two teams playing each year, you just know that every time they do, there will be something big on the line, and both fan bases will do whatever they can to watch it live. It may not have the name and cachet of the Holy War or the Silver Rail Rivalry, but to this sportswriter, this one has been a blast to cover, and I look forward to the next time they clash.

5

THE BAGLEY CUP

Olmsted Falls vs. Berea-Midpark

O lmsted Falls head coach Tom DeLuca grew up in Norwalk, Ohio. He was a football fan who idolized players such as Ronnie Lott as well as overall athletes like Dan Gable. Gable was one of the greatest freestyle amateur wrestlers of all time. Lott was an NFL Hall of Famer who is known as one of the hardest-hitting safeties of all time.

DeLuca is no stranger to the gridiron, as he played football in high school at Norwalk and then in college at Baldwin Wallace. He began his coaching career with BW as a student coach before landing with Tiffin Columbian High School. Eventually, his path in coaching led him to the SWC as the defensive coordinator for the Westlake Demons. He was there for four years before taking the head coaching job at Olmsted Falls.

Deluca commented on his choice to go after the Bulldogs job: "I had been the defensive coordinator at Westlake High School for four years. I wanted to try the head coaching deal, and I lived in Olmsted Falls when the position became available. I thought this would be a good position for me to go after."

Every good team needs a good rival, and this was no exception. As the school enrollment and the Bulldog program grew, so did a team and school just three miles down the road. In 2013, Berea and Midpark High Schools merged and took on the name Berea-Midpark, becoming the Titans.

As the schools were just three miles apart from each other and both played in the SWC, it was only natural that a rivalry would begin. It was christened the "Battle of Bagley Road." Both schools are located on Bagley Road. The Bagley Cup would be the trophy awarded every year.

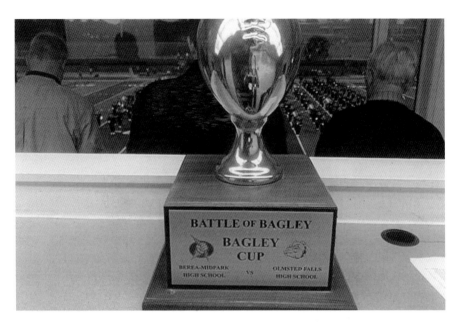

The Bagley Cup. *Author photo.*

Coach DeLuca talks a little bit about the importance of the rivalry:

> *Ever since Midpark and Berea merged, this has become a very big rivalry. We typically do not do anything special to get our players ready for the game. They know it's a big game and have been ready to go during this game. I think the location of our schools is a big factor in the rivalry. We have a trophy that we play for called the Bagley Road Trophy.*

The rivalry began in 2013 with a commanding 34–0 win for Berea-Midpark. Olmsted Falls struggled mightily that year, going 1-9. Berea-Midpark wasn't much better, finishing 3-7. In 2014, the Bulldogs improved drastically to 5-5 but still lost to their rivals by a score of 35–7. The Titans finished 8-3 that year and made the playoffs.

After the 2014 season, DeLuca was still new to Olmsted Falls but confident enough to realize they needed a change in style and in how they ran their offense. Ohio high school football was once known strictly for running the ball before many schools took on the spread and the hurry-up offenses. DeLuca was a firm believer that he could bring back the smashmouth style to Olmsted Falls and begin making waves in the SWC once again.

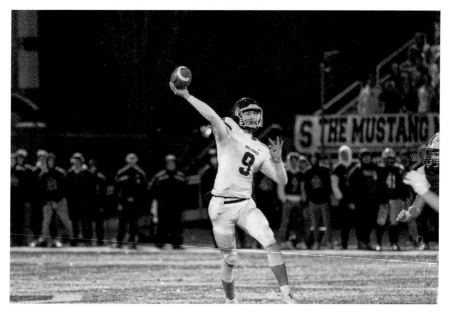

Olmsted Falls quarterback Charlie Ciolek looking to go deep. *Julie Spisak Herzog.*

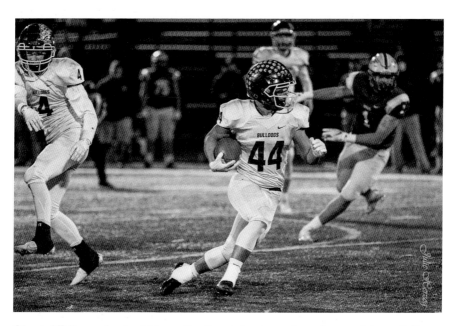

Olmsted Falls running back Rocco Conti sprinting toward another touchdown. *Julie Spisak Herzog.*

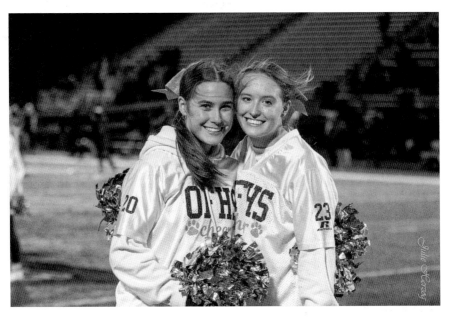

Olmsted Falls cheerleaders, 2015. *Julie Spisak Herzog.*

"After the 2014 season, our offensive coordinator left, and I was looking for a way for us to establish the run game," said Deluca.

> *I wanted to be different than everyone else, and I wanted to make it challenging for opposing defenses to plan for us. Our offensive line coach at the time was Carlos Rivera, and he had a lot of experience in the triple-option offense. As I was deciding on which route to go, I would watch and learn as much about the offense as possible. I would spend time watching Army/Navy games and trying to stop the offense in my own mind.*
>
> *I would call Carlos with my ideas and ask how he would attack my plan. He always had an answer of how to attack the defense. I loved that about the offense. There was always an immediate answer in the system as to what the defense was doing. After a couple of months, I decided this was the route for us to go.*

So confident in the system was Deluca that they began installing it right away, not only at the varsity level but also at all levels of the Olmsted Falls football program, starting in the youth football leagues and then junior high. This decision in itself is genius, because it has the young men ready to go by the time they reach varsity.

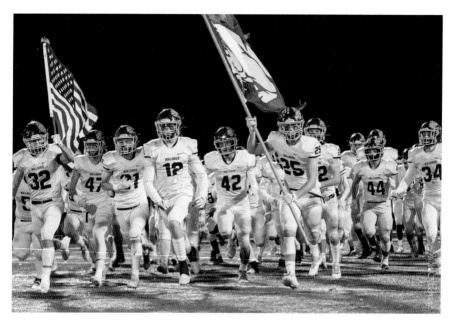

The Bulldogs are pumped to take on the Titans. *Julie Spisak Herzog.*

The third edition of the game, which took place in 2015, stands out as one of the best versions. The Olmsted Falls Bulldogs captured a nail-biter, 30–27. There was magic in the air for Coach DeLuca and his Bulldogs. They overcame an injury to their leading rusher in school history, Spencer Linville, to win the game. This came thanks in part to Noel Caroballo, who went off for 200 yards in only three quarters of action and then turned around and played defense, racking up 17 tackles.

The game came down to the very end, when an exchange of field goals went in favor of the Bulldogs. Ricky Castrigano made his kick for Olmsted Falls, and the Titans missed theirs.

Coach DeLuca looks back to that night and explains why it was a nice launching point for his program and the rivalry, along with a promise that led to him sleeping on the 50-yard line:

> *I feel that night propelled Olmsted Falls football, during my tenure, to where it is today. There are so many great memories from that game.*
>
> *They were a very talented team that year and we knew we were going to have to play a great game and stick to our style of football. It was a very physical game and we just stuck to our plan to run the ball and try to create*

Rocco Conti of Olmsted Falls runs for another touchdown. *Julie Spisak Herzog.*

Coach Carlos Rivera celebrates with McCabe. *Julie Spisak Herzog.*

turnovers. It was a back-and-forth game and was decided by both teams attempting field goals on their final drives.

One funny story is that I promised the players in the summer that when we beat Berea on our homecoming game that I would sleep on the 50-yard line. That night, a bunch of players and I slept on the 50-yard line. That was a big win for us and propelled us into future success.

By the time 2016 rolled around, both programs were running their offense on full steam, and it led to a streak of high-scoring games between the two. In the 2016 edition from Berea, the Bulldogs arrived to defend the Bagley Cup with a dominating 75–38 win.

Fast strikes and huge plays were on display for the Bulldogs that evening. They wasted no time on a two-play, 81-yard drive to start the night. The score was courtesy of a 79-yard strike from Brett Hutkay to Tyler Neely to hand the Bulldogs an early 7–0 lead. They were far from done.

The Titans got back in it quickly with a Tyrese Holland touchdown run as part of a four-play drive that went 54 yards. Holland had a monster night, running for 235 yards on 22 carries and scoring all 6 of Berea-Midpark's touchdowns.

The Bulldogs responded with a 4-yard run by Michael Howard and a 61-yard interception return by Andrew Turski. The Titans answered with a Holland 10-yard touchdown run as the fast-paced and high-scoring quarter ended at 21–14 in favor of the Bulldogs.

The blitzkrieg of offense continued in the early moments of the second quarter with a six-play, 76-yard drive capped off by Spencer Linville to give the Bulldogs a 28–14 lead. On the next Bulldog drive, Turski scored on a sharply thrown ball by Hutkay for a 48-yard touchdown pass. The extra point failed, and Olmsted Falls was on its way to a blowout, up 34–14.

The Titans refused go away quietly in this game and scored on a 75-yard run and a 14-yard run by Holland to cut into the lead. Hutkay connected one more time with Josh Goodwin on a 65-yard launch to put the Bulldogs well ahead at the half, 48–32.

The Bulldogs put it away for good in the second half with scoring plays of 5, 13, 1 and 44 yards. They were championed by the rushing of Linville, who had 16 carries for 105 yards and 2 touchdowns. Bulldog rocket-armed quarterback Brett Hutkay compiled 225 yards on 5-of-6 passing and 3 touchdowns, and he ran for 114 yards on 8 carries and 1 score in the rivalry win.

Charlie Ciolek gets wrapped up by a Titan. *Julie Spisak Herzog.*

A big tackle for the Titans. *Julie Spisak Herzog.*

The Olmsted Falls Bulldogs get ready for another epic clash with the Titans. *Julie Spisak Herzog.*

Three-year starting quarterback Luke Devins was a difference-maker for the Titans. *Julie Spisak Herzog.*

It was a big win for the Bulldogs. Coach DeLuca had this to say about the team's performance and the play of Hutkay and Spencer Linville:

We felt like we needed to keep scoring, because they started the game off scoring fast and often. We have had a number of games with them where we have scored every possession or close to it.

Brett had a heck of a game that night. He really stepped up his senior year and had a great season. He made so much improvement from his junior to senior year.

We had a lot of guys contribute that night, so I feel like Spencer didn't have his normal high-yardage type of game. I also think we pulled him in the fourth quarter.

That night, a young man by the name of Jack Spellacy, who was a sophomore at the time, saw action in the big game and played well. Quite honestly, Jack is one of the all-time favorite players I've ever covered. He not only worked his tail off but also did it with a smile on his face and was a great teammate to be around.

Coach DeLuca shares what made Jack so special:

Jack was a great football player for us. He ended up being a first-team All-Ohio pick as a senior. He is third all-time single season in rushing and third all-time in rushing in school history. But the best thing about Jack is the type of person that he is. He treated his peers with the utmost respect. All-around great person!

Headed into 2017, little had changed about the emotion of the rivalry and the intensity of the games. The Olmsted Falls Bulldogs welcomed the Berea-Midpark Titans on the cusp of riding a 4-game winning streak. They used their furious run game to bite the Titan defense on their way to a 62–49 victory in a game that lasted longer than most celebrity marriages. In fact, during that game, the Cleveland Indians hosted the New York Yankees in a divisional playoff game at Progressive Field that went extra innings. The talk in the crowd was, which game would end first?

The game saw 129 plays from scrimmage for 1,154 total yards. In all, 16 touchdowns were scored for a combined 111 points. It came close to matching the prior year's incredible 75–38 slugfest point total.

If it wasn't for the game's two missed extra points, it would have matched that 113-point total. On a separate note (and one that still has this sportswriter

Bulldog pride. *Julie Spisak Herzog.*

Berea-Midpark wideout Devan Borders. *Julie Spisak Herzog.*

Running back Rocco Conti heads for a Olmsted Falls score. *Julie Spisak Herzog.*

scratching his head), the game also saw a ridiculous 11 personal fouls—a shocking stat for two well-coached, normally disciplined teams.

Coach Tom DeLuca reflects on that night:

> *The one thing I remember about that game is we jumped up on them quick in the first quarter, 14–0. From that point on, we just said we needed to stay up by 14. At no point in that game did we ever feel we had it in the bag. Maybe when the clock struck zero. Berea-Midpark can score points with the best of them.*
>
> *I never really feel like we have any game secured when playing those guys. I am not really sure why there were so many personal fouls that night. I do know that this game had a lot to do with keeping the rivalry alive!*

As for the performances of Lombardo, Nick Dailey and Spellacy, DeLuca chimed in with this:

> *Each one of these players were different in their own way. I think Jack was so well-rounded in every aspect. Luke was one heck of an athlete, he was a big physical kid and had great instincts. Nick was a throwback, tough, hard-nosed kid. He probably weighed 160 pounds and started on both sides of the ball. Just tough as they come.*

This game has been a high-scoring game from both teams' offenses. I don't think the word satisfying when it comes to our point total, more so the right word I would say is necessary. Both teams typically score a lot in this game for some reason. We have had some games that look more like a track meet.

Jack Spellacy ran for 87 yards on 15 carries while scoring 2 touchdowns. Luke Lombardo was the Bulldog star of the game, as he carried the ball 12 times for an incredible 157 yards and 3 rushing touchdowns. Nick Dailey chipped in with 128 yards on just 8 carries while scoring 2 touchdowns himself.

Their multitalented quarterback, Teddy Grendzynski, also joined the mix with 85 yards on 6 carries, scoring a touchdown as well. The Bulldogs as a team, with the addition of the yards by Michael Howard (32), finished with 494 combined rushing yards on 51 carries. They only attempted 4 passes, all of them completions for Grendzynski, who compiled 108 yards on those completions with 1 touchdown.

Remarkably, despite the nonstop barrage of Bulldog points, yards and big plays, the player with the best stats in the game came from the losing team. Berea-Midpark running back Bryce "The Beast" Agnew finished

Julie Spisak Herzog.

Julie Spisak Herzog.

Julie Spisak Herzog.

Julie Spisak Herzog.

with an outstanding 181 yards on 18 carries with touchdown runs of 45, 2 and 53 yards.

The Bulldogs pounded the ball on the ground early and often, to the tune of three first-quarter touchdowns that allowed them to build a 21-point lead. The Titans managed to get a key turnover to stop the bleeding late in the opening quarter after crafty downhill running by the ever-hungry Agnew got them into scoring position. It was Trevor Bycznski on a quarterback rumble from 7 yards out to get the Titan attack on the board. I cannot stress this enough: Agnew drove with his legs to break several tackles on that drive and kept the Titans in it.

The Bulldogs wasted no time answering the Berea-Midpark score with one of their own. This time, it was the speedy Luke Lombardo flying in from 26 yards out. Lombardo showed the speed of a track star and had the jets that scouts at the NFL combine look for. The Titans then showed the heart they are known for, as Bycznski capped off a multiplay drive to strike back with a 13-yard touchdown toss to Omar Siggers to make it 28–14 at the half.

The Bulldogs wasted no time yet again, taking the opening drive of the second half into the end zone. Once again, it was Nick Dailey with the honors on a first and goal from the 20, taking it to pay dirt for the Bulldogs' 5th rushing touchdown of the night.

Olmsted Falls celebrates the 2016 Bagley Cup win. *Julie Spisak Herzog*.

Julie Spisak Herzog.

Olmsted Falls running back Rocco Conti sprinting toward another touchdown. *Julie Spisak Herzog.*

If the game was over, someone forgot to tell Agnew, as he rumbled in from 45 yards out on the very next Berea-Midpark possession. Lombardo for the Bulldogs then took his turn, scoring from 9 yards out to give Olmsted Falls their 3-touchdown lead back, 41–21. From there, they slugged it out a little bit more, to the tune of 6 touchdowns by the end of the third quarter, which saw Olmsted Falls build the lead to 49–28 by the time the quarter was over.

Down 21 points to start the fourth quarter, Bryce "The Cannonball" Agnew steamed down the field like a rocket, ripping off a 53-yard touchdown run that left Bulldogs yards behind, panting to catch up. From there, both teams continued to fire away with touchdowns at will, but Berea-Midpark was never able to close the gap closer than 13 points, and the final score was 62–49.

The Bulldogs would stay hot, win out and make the playoffs, where they had the Midview Middies waiting for them. The game was in Olmsted Falls and featured a thrilling finish after a wild back-and-forth game.

Once again, the incredible rushing attack of the Olmsted Falls Bulldogs proved to be too much to contain. The Bulldog triple-headed rushing monster compiled 218 rushing yards in a 26–23 victory over the Middies to advance to the second round of the state playoffs. The leading rusher was Michael Howard with 108 yards and 1 touchdown on 10 carries.

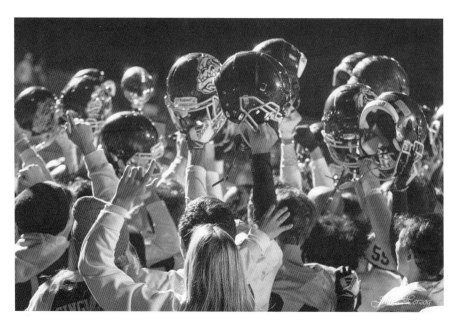

Bulldog pride is on display. *Julie Spisak Herzog*.

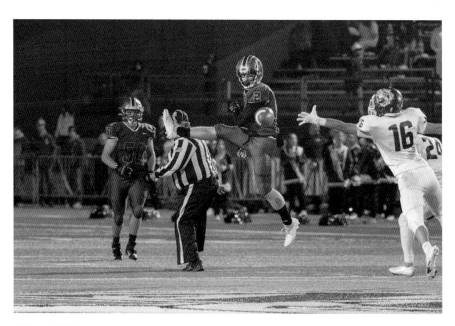

Olmsted Falls running back Rocco Conti sprinting toward another touchdown. *Julie Spisak Herzog*.

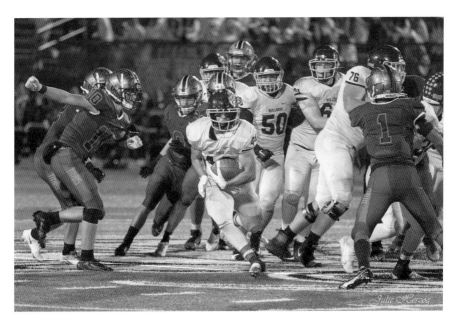

Tom DeLuca slept on the 50-yard line after his Bulldogs beat the Titans in 2015. *Julie Spisak Herzog.*

A trick passing play in the closing seconds secured Olmsted Falls one of the most dramatic wins in OHSAA playoff history. Running back Jack Spellacy threw a 60-yard halfback pass touchdown to Braden Galaska with forty-two seconds left on the clock to win the game. No one saw the play coming, and it proved to be a genius call by Head Coach Tom DeLuca to win his team the game in shocking fashion.

"We'd been in 4 games in the last two years in which we had to come on a two-minute drive to win the game," said DeLuca, who took us behind his thought process at the time of his gutsy call.

> *We're not afraid to run the ball on those two-minute drives, thus a defense cannot just play us in a prevent defense and not account for the run. Their safety and their corner both bit on the halfback lead, and we threw it over the top. We have been practicing it for the last four weeks, and thank God we did!*

Coach DeLuca went on to say that they he did not call the play.

> *I was actually discussing a call with the official between plays while Coach Rivera made the call. It was kind of funny, because I was getting after the*

official a little bit and jumped back on the headset and asked, "What do we have called?" Carlos said, "58 lead pass." I was a little surprised and said, "Sounds good." It was kind of a calm moment prior to the play, and then we hit for 6. It was really exciting. Coach called the play because a few plays earlier in the drive their corner and safety bit on 58 lead so hard that we thought we could get over the top. Luckily, we did.

The craziest part of it all was that only ninety seconds earlier, it was a trick play by Midview that gave them a 23–20 lead with two minutes left. Midview was down, 20–17, at the time with a few ticks over two minutes remaining on the clock when they ran a double reverse that allowed wide receiver Ben Gendics to break off a 64-yard touchdown run that appeared to seal the victory for the Middies.

It was their first lead of the game and, for all intents and purposes, appeared to be enough to vault the Middies into the second round of the playoffs. But the Bulldogs were not done, leading to the dramatic finish.

While the Bulldogs were coming off a playoff run in 2017 heading into 2018, the Titans had a slew of talented seniors coming back that had them off to a 4-2 start and talking playoffs themselves. Heading into that

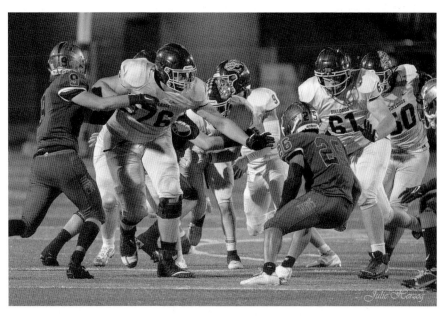

Julie Spisak Herzog.

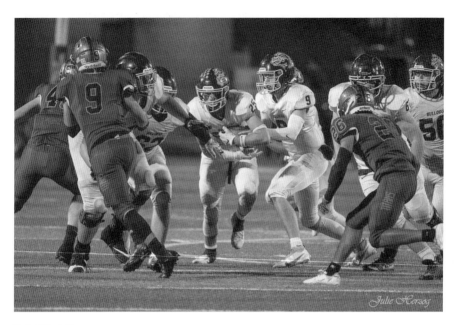

Julie Spisak Herzog.

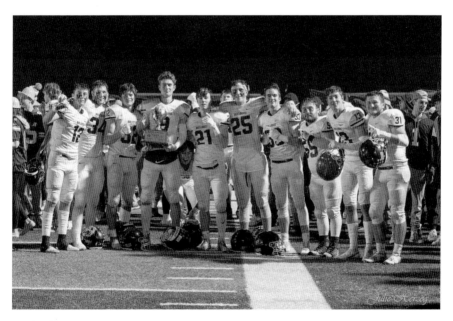

Bagley Cup winners. *Author photo.*

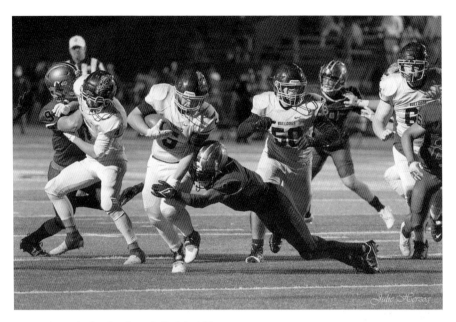

Action from the Bagley Cup. *Julie Spisak Herzog.*

game, quarterback Trevor Bycznski and tailback Bryce Agnew were putting together incredible senior seasons and gave the Titans a chance to do big things. They were personally 0-3 against Olmsted Falls in the rivalry, and this was their last chance to win the Bagley Cup while playing high school varsity football.

A full-blown shootout was expected to occur that night at Finnie Stadium in Berea, as over their last two meetings the teams combined to score 224 points. The two high-powered offenses once again didn't disappoint, as the Titans defeated the Bulldogs, 70–57, in yet another high-scoring affair for the Bagley Cup.

Both quarterbacks moved the ball early and often. Teddy Grendzynski did it mainly with his feet for Olmsted Falls, running for 101 yards on 7 carries, scoring 2 touchdowns. He also ran for a 2-point conversion.

Trevor Bycznski of the Titans continued his monster senior season with 375 yards in the air on 18 of 27 passing with 5 touchdowns. The strong-armed quarterback was well on his way to shattering every school record by the time he was done. His touchdown passes consisted of 56, 71, 63, 29 and 25 yards.

He didn't do it alone, however, not by a long shot. He had plenty of weapons all night, and they all had career games. Running backs Jabriel Williams and Bryce Agnew combined for 306 yards rushing on an incredible

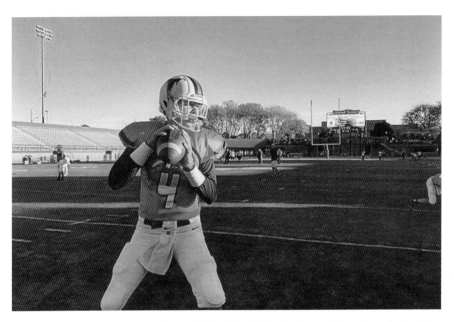

Trevor Bycznski showed up in at Berea-Midpark in 2015 and changed the culture. *Author photo*.

Bycznski gives his team a pep talk pregame against Olmsted Falls in 2016. *Author photo*.

Bryce Agnew of Berea-Midpark will go down as one of the best players in Bagley Cup history. *Author photo.*

night. Agnew scored twice on the ground with carries of 4 and 59 yards. Agnew also scored on a dump-off pass that he took to the house from 24 yards out. When Agnew started running downhill, opposing defenses needed to gang-tackle him to have any chance at bringing him down.

Williams was every bit as incredible that night. Simply put, the young man could not be stopped. Williams piled up 178 yards on only 12 carries, scoring 3 touchdowns of 27, 34 and 64 yards. Williams was the game-changer; he couldn't be tackled. When both Agnew and Williams were getting their touches, the team was nearly impossible to stop.

The big targets through the air for Bycznski included Garrett Waite (151 yards on 7 catches). He scored 2 touchdowns of 56 and 29 yards. Dwayne Holland was also not to be denied (147 yards on 3 catches). He also scored 2 touchdowns, from 71 and 63 yards.

As amazing as all of that was, the biggest stat line of the night came from a player on the losing team for the second straight year. Jack Spellacy of Olmsted Falls had the game of his life. Spellacy finished with 400 rushing yards and 5 rushing touchdowns of 57, 43, 5, 68 and 42 yards. He also caught a pass and took it 60 yards for a touchdown, giving him 6 for the game. The Bulldogs as a team ran for 528 yards.

DeLuca had this to say about Spellacy that night and his entire Bulldog career:

> *Jack was one of the greatest players that I have ever had the opportunity to coach. He really had everything you were looking for in a player. Outstanding strength, speed and football knowledge. He was a great leader! And he was a fantastic person, he always treated everyone with respect!*

The two teams combined for over 1,000 total yards, 127 points, 19 scores and 18 touchdowns. It was a wild game for sure, and it had Berea-Midpark head coach Jon Hunek extremely proud of his team afterward.

The Bulldogs stunned the Titans by converting an onside kick to start the game. Four straight runs later saw Grendzynski rumble in from 4 yards for the game's opening score. The Titans wasted no time, scoring only minutes later on their opening drive. The Titan score came courtesy of a 4-yard Bryce Agnew scamper. Agnew had 4 carries on the drive for a quick 23 yards. Shockingly, no more points were scored by either team for the remainder of the quarter.

The Titans used Anthony Miller as a battering ram for 6 straight runs the first time they touched the ball in the second quarter. It was a good way to

Olmsted Falls secures a big turnover. *Julie Spisak Herzog.*

Scoring another touchdown is Olmsted Falls running back Rocco Conti. *Julie Spisak Herzog.*

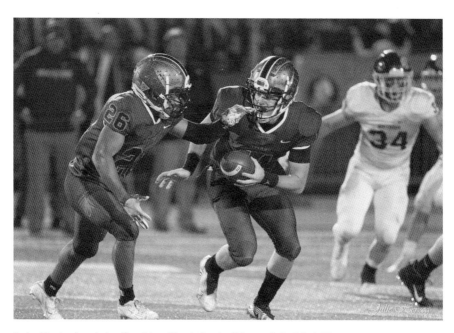

Luke Devins hands it off to his tailback for the Titans. *Julie Spisak Herzog.*

Another Bagley Cup win for the Bulldogs. *Julie Spisak Herzog.*

settle down Bycznski after an early pick. The Titans couldn't cash in with a touchdown, as the drive eventually stalled. However, they did pick up 3 points on an impressive 39-yard field goal by Nick Ruggiero.

Any thoughts of a low-scoring game quickly went out the window, as the rest of the quarter became a shootout. Olmsted Falls poured on the offense with 2 touchdown runs by Spellacy, one of 57 yards and another of 43 yards. Grendzynski would have one of 63 yards as well.

Coach DeLuca spoke about what made Grendzynski such a special player:

> *Teddy was one of the smartest football players I have ever coached. When he was a senior, he would call the play before coach would be finished giving the signal. He was in sync with what Coach Rivera was thinking and could execute the offense very well. Teddy was one of the best quarterbacks in the area. I think he threw 22 touchdowns to 2 interceptions that year. He was also an outstanding baseball player.*

As impressive as the Bulldog attack was, the Titans answered with an even better one. Bycznski tossed touchdowns on 3 straight passes covering nearly the entire field. The damage saw touchdown passes to Holland of 71 and 63 yards and to Waite of 56 yards. The scoring blitz also saw Williams bust off a beautiful 27-yard touchdown run.

Jabriel Williams would continue his big night in the third quarter with another long touchdown run. This time, he put it in from 34 yards out. The quick strike gave the Titans their largest lead of the night at 43–28.

As it was in the first half, the Bulldogs wasted no time in answering with a score of their own. It was Jack Spellacy scoring his 3rd touchdown of the night, this time from 4 yards out. The 2-point conversation was good by Grendyznski, closing the gap to 43–36 with 1:43 left in the third quarter. The quarter ended by that same score.

The fourth quarter picked up where the third quarter left off. Bycznski threaded the needle perfectly as Garrett Waite caught his second touchdown pass of the game, this time from 25 yards, to give the Titans a 50–36 lead with 10:51 left to play. The Bulldogs weren't fazed, however, and Jack Spellacy took off one play later for a 68-yard touchdown run.

Coach DeLuca gives his thoughts on why Bycznski was so tough to stop that night:

> *Well, I remember that our best cornerback, Michael Howard, did not play that evening, so we had adjusted our coverage for this game. It was a mistake on my part to do this. We would have been better off playing our normal defense and just trying to slow Trevor down. We would not have been able to stop him, but we maybe could have eliminated a few of those big plays.*

This latest score, his fourth, made it 50–43 Titans following the extra point with 10:33 to play. Two plays later, the Titans scored on a terrific Agnew 59-yard run that saw him break no less the 5 tackles.

This latest score in the blitzkrieg of points made it 57–43 with 9:43 left. Olmsted Falls head coach Tom DeLuca dialed up Spellacy once again. This time, he steamrolled for a 42-yard touchdown. It was his 5th of the night to cut the lead to 57–50 with 8:36 to play. Agnew would answer, taking a dump-off pass from Bycznski 24 yards to pay dirt, increasing the Titan lead to 64–50.

It wouldn't last. Seconds later, it was Spellacy again, this time through the air on a 60-yard hookup with Grendzynski, cutting the lead to 64–57 with 6:53 left. Two plays later, the Titans took their turn, a 64-yard touchdown rumble by Jabriel Williams. The extra point was no good, and the score rested at 70–57 with still over six minutes to go. It was a total of 7 touchdowns in less than six minutes to begin the quarter. Remarkably, no one else would score the rest of the game.

With the loss, the Bulldogs fell to 5-2; the Titans rose to 5-2. Amazingly, the Titans went on to lose 3 straight games to end the season to Avon Lake,

North Olmsted and Avon. Meanwhile, the Bulldogs went on a tear, beating their last three opponents, including undefeated Avon Lake in a classic at home in week nine, to eventually make the playoffs. They then lost to Avon Lake in the first round.

Coach DeLuca touches on how his Bulldogs were able to turn around from the loss, to rebound so strong and beat Avon Lake a few weeks later on their way to the playoffs: "That senior class was very talented in so many ways. They were great players but also had great leadership! It was not surprising to me that we were able to move on from that loss and finish the season strong."

After the epic encounter in 2018, the next two years lost some of the luster, as Berea-Midpark encountered a rebuilding year in 2019, when Olmsted Falls defeated them, 36–21. The two teams didn't hook up in 2020 for the first time in the rivalry because of COVID-19.

While the two teams went without the clash in 2020, it meant the most it ever did, as it was moved to week ten of the 2021 season. At the time, both teams knew they were going to the playoffs, but seeding was on the line for Berea-Midpark. If Olmsted Falls won, they would share the conference title with Avon. All of these factors led to an amazing and high-scoring game.

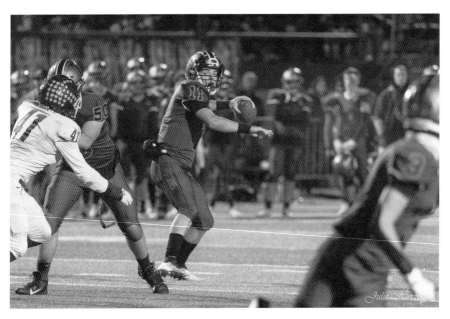

Luke Devins gets ready to launch another touchdown pass for the Titans in 2021. *Julie Spisak Herzog.*

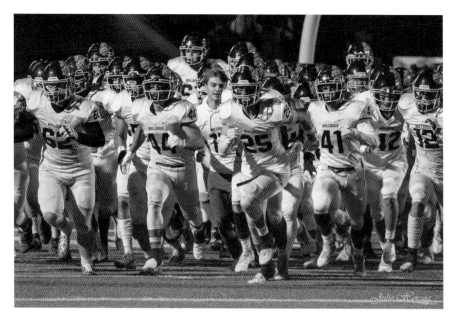

The Bulldogs take the field for the Bagley Cup. *Julie Spisak Herzog.*

Bagley Cup game action, 2018. *Julie Spisak Herzog.*

Titan quarterback Luke Devins hands it off. *Julie Spisak Herzog.*

Olmsted Falls quarterback Charlie Ciolek, 2019. *Julie Spisak Herzog.*

The Bagley Cup and a share of the SWC title was on the line as the Olmsted Falls Bulldogs traveled to Berea-Midpark to take on the Titans. It was a high-scoring affair that saw the Bulldogs defeat the Titans, 63–49, as Rocco Conti scored 7 touchdowns. The Bulldogs won the cup and tied the Avon Eagles for a share of the SWC championship.

As mentioned, young Rocco Conti had a night to remember during a season in which he became one of the top rushers in the state. Conti finished with 217 rushing yards to go along with the 7 touchdowns. He did all of this on 21 carries.

He had plenty of help back there, as Charlie Ciolek ran for 107 yards and 1 touchdown on 10 carries. Ciolek is one of the best rushing quarterbacks the SWC has ever seen. Michael Candow got in on the fun with 45 yards on 9 carries, while Clay Vormelker had 40 yards on 10 carries. Luke Dieckman stayed hot as well, scoring again and rushing for 36 yards on 12 carries.

While the Bulldogs went to the ground, the Titans put on an air show that will also be remembered for a long time to come. Senior quarterback Luke Devins tossed for 270 yards on 22 of 35 passing with 2 touchdowns and 2 picks in his final home game as a Titan quarterback. Luke also ran for 24 yards with 2 touchdowns on 9 carries. It was my pleasure to cover Luke these three years. He is a great young man from a great family. His younger brother Hudson Devins also had a nice night, with 58 yards on the ground and 20 yards receiving. Hudson had a touchdown run as well.

What can I say about this Titan receiving corps? They are incredibly talented and dangerous and showed why again in this game. Devin Johnson had 111 yards receiving on 8 catches with 2 touchdowns. He was everywhere. Jack Arnold had 7 catches for 74 yards and 1 touchdown. DeAngelo had another fine game, one of many for him that season (75 yards receiving on 4 catches).

The Bulldogs used their vaunted run game to march down the field on the game's opening drive. They went 75 yards in eight plays to score on a Conti 1-yard touchdown rumble. Seven of the nine plays were runs, accounting for all of the yards. The big play coming from a Charlie Ciolek run that went 39 yards. They missed the kick however, and the score remained 6–0.

The Titans would answer right away the first time they touched the ball. A seven-play drive mixed perfectly Hudson Devins runs and Luke Devins pass connections to Devin Johnson, Jack Arnold and DeAngelo Borders, leading to pay dirt. The drive capped off with a 9-yard pitch-and-catch to Devin Johnson to tie the game at 6. The game remained tied, as their point-after attempt was blocked.

The next Bulldog drive would be halted by a leaping Cameron Cupach interception. It was another nice mixture of run and pass on the ensuing Titan drive. Once again, everyone got in the mix, with runs by the Devins brothers and sharp passing to Devin Johnson, Jack Arnold and DeAngelo Borders. A 2-yard Aquan Bell touchdown run finished it off. Moments later, it was Bell catching a 2-pointer in the corner of the end zone to give the Titans a 14–6 lead with fifty-six seconds to go in the first quarter.

A 48-yard Rocco Conti kickoff return set the Bulldogs up in great shape, as they started their next drive on the Titan 41. Rocco would then do the bulk of the damage on the drive, accounting for all the yards and finishing things off with a 33-yard touchdown run. Conti is just fun to watch! The 2-point conversion attempt failed, and the score remained 14–12, Titans.

The Bulldogs would get the ball back a little bit later in the second quarter and go right back to work on the ground, methodically pacing their way toward the end zone. Big runs by Ciolek of 15 and 10 brought them inside the red zone. Finally, another 15-yard run by Ciolek finished it off. They'd go for 2 points yet again and this time get it in with another Ciolek run to lead 20–14 with 8:31 to go in the opening half.

Charlie Ciolek was a special player who had to buy in early into his career to make it work. Coach DeLuca knew that and had these thoughts on Ciolek: "Charlie is one of those rare three-year starters. He has been in the fire, as we say, for a long time. He really had an outstanding senior year! I think when you can couple his understanding of the game with his outstanding athletic ability, you have the chance to be really special."

The Titans were not fazed by the sudden deficit and began their next march toward scoring. This time, it was capped off by a Luke Devins dash up the middle to make it 21–20, Titans, with 6:04 left in the half. The drive was aided by a long pass-interference call on the Bulldogs.

A Rocco Conti 44-yard touchdown run was called back moments later, but that didn't matter. A few plays later, it was Conti speeding in from 35 to score for the Bulldogs. A 2-point conversion was successful, and just like that, it was Olmsted Falls leading, 28–21, with 1:23 to play in the half. The half was far from over, however.

Conti would punch it in again to make it 35–21. Conti had 4 touchdowns in the first half alone at that point. A two-minute drive by the Titans was halted on a Jack Pinchek interception that was returned nearly 70 yards to the Titan goal line with exactly one second to go. Then the Bulldogs called up Conti one more time, and he put it in to make it 42–21 at the half. It was a 5-touchdown performance in the first half alone as the Bulldogs

scored 35 second-quarter points. It was insanity that only the Bagley Cup can bring.

Down 42–21 to start the second half, the Titans came out a hungry team, and Jack Arnold took the opening kickoff all the way to the Olmsted Falls 27-yard line. A 13-yard pass to Arnold moments later put them in scoring position. A few Hudson Devins runs eventually set up a Luke Devins touchdown scramble to cut it to 42–27 as the kick was missed with 9:40 to go in the half.

The Bulldogs and Titans continued to trade touchdowns as the third quarter went on. By the time the quarter came to an end, it was 49–35 as the teams entered the final twelve minute of the game.

The Bulldogs began the fourth quarter where the third quarter left off, running the ball! They were aided by great field position from a recovered onside kick to start things off in Titan territory. They kept running the ball, grinding up clock and yards before Conti punched it in for his 6th touchdown of the night. The Bulldog lead grew to 56–35.

The Titans wasted no time flying down the field as Devins carved up the secondary. They capped off the mad dash for points with a beautiful touchdown pass in the corner of the end zone to Jack Arnold from 18 yards out to cut the lead to 56–42.

Rocco Conti scored his 7th touchdown of the night to stretch the lead to 63–42 with 1:58 to play. The Titans answered one more time with a Devin Johnson touchdown catch. It was too little, too late as the game concluded 63–49.

When these two teams hook up, you can always count on plenty of points being scored. The games in 2017 and 2018 both saw the teams combine for over 120 points each game. This night was no different, as they combined for 16 total touchdowns and 112 total points.

Coach Tom DeLuca understood just how big and important this rivalry win was:

> *We knew going into the year that week ten was going to be a huge game. We actually scheduled a practice at BW's field for one of our camp days in the summer so the kids could have a little familiarity with the facilities prior to our game. I felt like this paid off for us.*
>
> *The environment for this game was an amazing high school experience. There were a ton of people, and the crowds were great! It was fun celebrating a share of the SWC crown! It will be a lasting memory, for sure. I didn't even realize Rocco had so many touchdowns until after the game. Rocco is a special type of kid. He is very similar to Jack Spellacy. Great player and athlete and even better person.*

Who knows what memories 2022 and beyond will bring to this rivalry? Two great coaches and traditions continue to get better season in and season out. It's astounding the number of differences that exist between two schools just a few miles apart. The Titans are a high-flying offense playing on artificial turf that can put up punches in bunches. Olmsted Falls features a methodical attack that wears down the opposition and breaks their spirit.

Coach DeLuca had these final thoughts on the great rivalry, along with just what makes Friday nights in the fall so special:

> *When I first started at Olmsted Falls, I was told that North Olmsted was our rival. You could also throw Avon Lake into the mix in that rivalry talk going back a long time, when Coach Ryan and Coach Dlugosz were battling it out.*
>
> *But when Midpark and Berea merged, it became a natural rivalry fueled by the kids! I think this rivalry has grown over the years not just through football but with all of the sports. This is what high school sports is all about. The kids will remember these games for years to come.*
>
> *Friday night lights are a chance for everyone in a community to put all of their differences aside for a moment and just cheer for their community. No one cares about all of the controversies in the world and they can just have fun and be a part of the Friday night experience.*

If I was going to sum up the Bagley Cup rivalry, the best way I can do it is by saying this: It is two blue-collar towns just a few miles apart that are in it for the right reason. When you buy your ticket and take your seat for the game, expect a lot of emotion and a ton of points!

Here are the results of the rivalry games since 2013:

2013 34–0, Berea-Midpark
2014 3–7, Berea-Midpark
2015 30–27, Olmsted Falls
2016 75–38, Olmsted Falls
2017 62–49, Olmsted Falls
2018 70–57, Berea-Midpark
2019 36–21, Olmstead Falls
2020 No game
2021 63–49, Olmsted Falls

STATE-BOUND DRAMA

Hoban vs. Avon

When you're the Archbishop Hoban Knights, you become so good that you start to develop rivals everywhere. Another one that has formed in recent years is with the Avon Eagles out of the SWC. While Avon will tell you that their number-one focus is the game ahead of them as well as the Avon Lake Shoremen, these feuds with the Knights of Hoban have really heated up over the years.

It all started in 2017, when the Avon Eagles began their stretch of five straight trips to the state final four. In four of the last five years, that game has taken place against the Archbishop Hoban Knights out of Akron. Each one has been closer than the last and has featured some of the greatest players in OHSAA history.

The 2017 OHSAA playoffs state semifinals took place on November 27, 2017, from a frozen Brunswick Auto Mart Stadium. All eyes were on Brunswick as an epic clash between Avon and Archbishop Hoban took place for a ticket to the state championship game in Division 2. Both teams played hard, and in the end, it was Hoban handing Avon their first loss all year with a 30–6 victory.

The Hoban Knights powered their way to the victory with a relentless stampede of rushing the ball down the gut of Avon. After a tight first half in which Avon did a great job of clock control, yet still trailing, 10–6, at the break, Hoban pulled away in the second half.

Freshman Hoban quarterback Shane Hamm didn't do much in the air, but he didn't need to, as his legs were more than enough. The freshman quarterback rushed for 47 yards on 7 carries, scoring 1 touchdown.

Hoban tacklers wrap up Matt Erhardt. *Julie Spisak Herzog.*

Lamar Sperling leaps over a diving Avon Eagle. *Julie Spisak Herzog.*

Hoban wraps up Sam DeTillio. *Julie Spisak Herzog.*

Sophomore running back Deamonte Trayanum racked up 126 yards on 8 touches, also scoring twice. Making his stats even more impressive for Trayanum is the fact that he didn't touch the ball until the second half. He was also a force on defense, with a sack and an interception. Starting tailback Tyris Dickerson chipped in with 110 yards on 15 carries. He did not score. Avon simply had no answers for the relentless rushing attack of Hoban.

The Hoban defense was every bit as impressive, forcing Ryan Maloy into multiple interceptions and sacking him 7 times. It was clear the Eagles attack was running a little flat without Tony Ebhardt working at full speed. It was his first game back in several weeks after dealing with illness.

Avon converted a third and 14 for 24 yards on the opening drive. The team was then handed a 15-yard personal-foul call on Hoban tacked on to the end of the play on a late hit. Avon would convert their next third down with Nick Perusek on a third on 5. Perusek was only a sophomore, so it was a rare carry for the young back in such a crucial situation. However, it was then that Avon committed mistakes, as back-to-back penalties set up a second down and 35 from the Hoban 44.

A Ryan Maloy pass was intercepted by Hoban defender Garrett Houser, who took it all the way back to the Avon 20-yard line after about an 85-yard return on the Maloy overthrown pass that stalled the drive. The Eagles

defense forced the Hoban offense to a three and out. Hoban then converted a 35-yard field goal, as kicker Jacob Branham bounced it in off the post. The Knights had that kind of luck in the first half.

The ensuing kickoff saw yet another personal foul on Hoban, the second in the first seven minutes of the game. Ryan Maloy and the Eagles took advantage of the mental mistake and began another impressive drive. On the legs of Maloy, Avon drove the ball down to the 20 of Hoban territory again.

Avon went for it on fourth and 1 from the Hoban 12-yard line with 1:38 left on the clock. Hoban once again helped them out by jumping offsides to hand Avon the first down. It would pay off two plays later, as Maloy took it in himself from 7 yards out. The extra point was blocked, and it was 6–3, Eagles, with forty-five seconds left in the first quarter. It would be the last lead they held and the last points they scored.

Avon continued to make costly mistakes. After forcing a Hoban punt early in the second quarter, the Eagles fumbled the punt and gave the ball right back to the Knights, this time on the 22-yard line of Avon. The Archbishop Hoban Knights wasted no time cashing in, as quarterback Shane Hamm ran it in from 4 yards out a few minutes later, putting the Knights up, 10–6. Hoban was hit with their third personal foul of the game on the play after the touchdown.

From there, the Eagles strung together yet another double-digit play in a six-plus-minute-long drive to close out the first half. They advanced the ball to the Hoban 18-yard line when fourth and 8 approached. They opted against the field goal and decided to go for it. The Mike Elder gamble came up craps, as Ryan Maloy was rushed out of bounds, giving the ball back to the Knights with 58 seconds left in the half.

A strange first half muddled with penalties and turnovers saw Hoban run less than twenty plays and throw only 2 passes, and yet, they lead Avon, 10–6, at the half. Avon ran a ball-control offense and soaked up a lot of clock, but a blocked extra point, a turnover on downs and a red zone interception hurt them. Avon even outgained Hoban, 155 to 55 yards in the half, but it simply didn't matter.

Hoban started the second half with the ball and wasted no time cashing in. Hamm capped off the drive with a dashing 7-yard rumble to extend the lead. Avon was forced to punt and quickly gave the ball back to Hoban.

Once again, the powerful Knight offensive attack had no issues marching the ball down the field and scoring. This time, it was sensational sophomore Deamonte Trayanum sprinting in from 16 yards out. The extra point was

Avon Eagle Matt Erhardt dives between tacklers. *Julie Spisak Herzog.*

blocked, but the damage was done. Hoban now led, 23–6. Despite 5 personal fouls, the Knights were dominating. Trayanum put one more in before the night was over.

Hoban advanced to the Division 2 state championship game the next weekend from Tom Benson Stadium in Canton. They defeated Winton Woods out of Cincinnati, 42–14, for their third straight state championship and their first in Division 2.

Avon didn't have to wait long to get a rematch, as the two went at it again in the 2018 OHSAA playoffs state final four on November 23, 2018. The Eagles were one year more seasoned and ready to go, but it wouldn't matter. The Archbishop Hoban Knights returned to the Division 2 championship game by defeating a talented but overmatched Avon Eagles team, 42–7, for their 28th straight victory.

They used a combination of smothering defense alongside a high-octane running game to overpower the Eagles all night, once again from a frozen Brunswick Auto Mart Stadium. The Knights went on to play the Massilon Tigers in what was one of the greatest high school football games in the history of the OHSAA.

All season long, the Knights used a powerful running attack and well-balanced defensive style to outmatch any team they faced. That night,

Hoban quarterback Jayvian Crable. *Julie Spisak Herzog.*

Lamar Sperling breaks away for another touchdown. *Julie Spisak Herzog.*

was no different, as it was Tyris Dickerson rushing for 174 yards on 12 carries and scoring 2 touchdowns to catapult the Knights back into the championship game.

His running mate in the backfield, Deamonte Trayanum, was every bit as good, going for 104 yards on just 6 rushes and also scoring 2 touchdowns. Trayanum also leveled countless huge hits on the defensive side of the ball. The junior was being scouted by almost every major division 1 college out there, and for good reason.

In the second half, the Knights needed only 8 total plays from scrimmage to put up 21 points. To get a game to a running clock in a state semifinal is nearly unheard of. They were that efficient and that good.

The Knights started the game from their own 25-yard line and wasted no time marching down the field to score. A seven-play, 75-yard drive was capped off by a 43-yard burst by Eastern Kentucky commit Tyris Dickerson to open the scoring. It was a two-minute, fifty-six-second masterpiece by the Knights. They had two key third-down conversion pass completions of 10 yards each from Shane Hamn to Mason Tipton.

After forcing an Eagle punt, the Knights went right back to work. This time, a huge 39-yard pitch-and-catch from Hamm to Tipton moved the ball deep into Eagle territory. Moments later, it was Deamonte Trayanum rumbling in from 9 yards out to score. It was his 24th touchdown of the season on the ground, and it capped a five-play, 80-yard drive to increase the lead to 14–0.

The score would remain that way after one quarter of play was concluded. For the season through 14 games, they had outscored their opponents by 162 points in the first quarter. They were that strong, that fast, that extremely good.

Shane Hamm kept the offense rolling along the next time the Knights touched the ball with another impressive drive. Hamm did it all with his arms and feet, and the team had no issues piling up the yardage.

Hamm busted out runs of 9 and 12 yards on the drive before pounding it in from 2 yards out. For Hamm, that was his 9th rushing touchdown of the season. The drive was a swift six plays in a little over two minutes. Hamm hit Tipton for a 19-yard strike on that drive as well, to improve the score to 21–0.

The Knights took a commanding 21–0 lead into the break. For the season, in 14 games, they allowed a total of just 94 first-half points—an incredible average of 6.7 points allowed per game in the opening half.

The Avon Eagles opened up the second half with the ball, looking to get back into it. It was a seven-minute drive covering over 70 yards. A beautiful scramble by Ryan Maloy to get out of the pocket led to him finding a wide-open Ryan Jones in the back of the end zone for a 24-yard touchdown pass to get the Eagles on the board. Maloy had hit Jones earlier on the drive for a 16-yard strike as well.

The Knights wasted no time responding, with a 50-yard bomb from Hamm to tight end Caden Clark to start the drive. That was helped by a 15-yard personal foul to follow. Two plays later, the drive was capped off by a leaping 18-yard touchdown catch by fullback Matt Blanchard. All in all, three plays, one minute and four seconds and total domination to extend the lead to 28–7.

Down by three scores with the clock doing them no favors, the Eagles refused to give up and began to mount another drive. They entered deep into Knight territory as the game moved into the fourth quarter. A ten-play drive saw them advance to the Knight 14-yard line. It would fizzle out, however, as Devin Hightower picked off Maloy in the back of the end zone, effectively ending any doubt.

The Knights decided to put their own exclamation mark on the game when Tyris Dickerson took the next play 85 yards to the house. This ended

State final four action, 2021. *Julie Spisak Herzog.*

Hoban quarterback Jayvian Crable rushes in a touchdown. *Julie Spisak Herzog.*

Lamar Sperling just running over people. *Julie Spisak Herzog.*

all questions as to just how dominant this team was. As if there had been any question to begin with.

At 35–7, fans and family headed for the exits. They missed another Trayanum touchdown strike, as he sped in from 78 yards a few minutes later to cap the scoring at 42–7.

Shane Hamm finished 7 of 7 for 147 yards with 1 touchdown. Hamm also ran for 33 yards and 1 touchdown. He was the steady force that kept the Eagles defense guessing, allowing huge holes to develop for his two star running backs. Hoban would go on to win the greatest state championship game in OHSAA history over Massillon, as chronicled earlier.

The two schools managed to avoid each in 2019, as it was Massillon knocking off Hoban to collide with Avon in the final four. Sadly, for Avon, the result was the same, as Massillon could not be stopped. But now they got their chance with a rematch with Hoban with perhaps the greatest talent Avon has ever had. They had the momentum, too, coming off a thrilling last-second win over their rivals, the Avon Lake Shoreman, the week before. (See chapter 3.)

Down big early, Avon stormed back in the second half at a frosty Byers Field in November 2020. A 64-yard Kharion Davis pick six ended the dramatic Avon rally and gave the Knights of Hoban a 28–14 victory.

The Knights used an 80-yard, seven-minute drive over thirteen plays to start the scoring on their opening drive of the game. This was after a five-plus-minute drive came up empty on a Nathan Vakos 42-yard field-goal attempt that sailed wide right.

The Knights' touchdown came on an 11-yard Victor Dawson touchdown run. Dawson had a big night (17 carries for 110 yards and 2 big touchdowns). It was the Knights cashing in again with a stellar two-minute drive that started on their own 36 with only a minute and change to go to end the first half.

They got the ball back after an Avon Eagle drive went four and out on 4 straight incomplete passes after a shanked punt gave the Eagles great field position. The Knights finished it off with a 19-yard passing strike from Shane Hamm to Brayden Fox with eleven seconds to go in the half.

Fox had a big game with 5 catches for 85 yards and 1 touchdown. Hamm went 13 of 21 for 191 yards and that touchdown. His other big targets were Kharion Davis, who had 3 catches for 35 yards, and Shawn Parnell, who had 3 catches for 32 yards.

Being down is nothing new to the Avon Eagles. They don't blink in the face of adversity, and this evening was no different. After the opening

second-half Hoban drive stalled because of penalties, the Eagles took over near midfield and began their comeback attempt. It was a rough night for Hoban, penalty-wise, as they chalked up 133 yards on 15 costly penalties.

The Eagles scored on an 8-yard pass from Niko Pappas to the suddenly red-hot Timmy Conwell. Pappas rebounded from a slow first half to have a strong second half. Pappas finished with 144 yards on 14 of 26 passing with 1 touchdown and 2 picks late. Conwell finished the season strong with a 7-catch, 66-yard night.

Pappas did his best work with his feet, as he had all season. Pappas used big runs of 29 and 23 yards on back-to-back drives in the second half to get the Eagle offense cooking. The second drive resulted in a touchdown for the Eagles to tie the game.

A 16-yard pass to Mike Ptacek put them on the 2-yard line for first and goal. They rushed to the line, then Pappas lunged forward, breaking the plane to tie the game at 14 with 9:34 to go.

The Archbishop Knights aren't one of the top teams in the state year in and year out for no reason, and on this night they showed why. They calmly responded with one big play after another to retake the lead on a three-minute drive capped by a powerful 3-yard touchdown run by Dawson to reclaim the lead, 21–14, with 6:37 to go. The defense would seal the deal from there.

A little over 365 days later, it was insert tape and hit play—rematch number three was underway. Could this be the year the Eagles finally got past the Knights, in the 2021 state final four game? The Eagles came in red hot, having gone on a 9-game winning streak since losing to their rival, while Hoban had looked a bit shaky at times over the course of the season. If the Eagles were going to do it, this was their chance. (Portions of this recap are via Dom Clary of Kee On Sports Media Group.)

Once again, it was Black Friday, and once it again, it was snowy! Like 2020, the game was played at Byers Field in Parma. After each team had a promising drive stall to start the game, Avon quarterback Sam DeTillo and running back Jakorian Caffey dominated the drive with an impressive mix of passing and running. DeTillo capped off the drive with a 12-yard quarterback run that made the score 7–0 in favor of the Eagles.

Hoban wouldn't shy away from the challenge. Lamar Sperling once again carried his team down the field with a 30-yard run to put them in the red zone with only 2 short yards to go. The Eagle defense was stout, stopping Sperling and the triple stack power two plays in a row. Jayvian Crable completed a 4-yard touchdown pass to wide receiver Shawn Parnell for a touchdown to even up the score, 7–7.

Hoban looks to salt away another win late. *Julie Spisak Herzog.*

Avon's offense sputtered out on three plays, giving the ball back to Hoban's high-powered offense. Crable and Sperling dominated the ground as the quarterback and running back duo. Crable set up Sperling's 2-yard touchdown with a 56-yard run. This gave the Knights the lead, 14–7.

Avon tried to gain momentum; their drive ended before it could really start. A fumble killed the drive on the second play. The Knights got the ball at midfield. Hoban struck on their first play with a 47-yard touchdown pass from Crable to Rickey Williams to increase their lead by 7. This gave Williams his first touchdown on the year and gave Hoban a 21–7 lead.

Avon got the ball with just about six minutes left in the first half. They controlled the ball for almost all of those six minutes. Another drive with a good mix of runs and passes led the Eagles right down the field. DeTillo took it himself as he pulled Avon within 7 to make the score 21–14 in favor of Hoban at the half. Avon was convinced that this year would be different.

Then things got really crazy, as Avon hoped to stop Hoban at half to keep the game within one score. Hoban drove down the field and got into field-goal range with about twenty seconds left in the half. A negative pass to Sperling took Hoban out of field-goal range as they spiked the ball with only three seconds left.

Sam DeTillio was a profilic Avon Eagle quarterback. *Julie Spisak Herzog.*

Lamar Sperling. *Julie Spisak Herzog.*

It appeared that the Eagles would get out of the first half down by only one score, then they promptly shot themselves in the foot. Avon was penalized for having too many men on the field, and this put Hoban within field-goal range. Durkin hit the 39-yard field goal to give the Knights a 10-point lead at halftime, 24–14.

Hoban got the ball to start the half and drove down the field thanks to a 45-yard run by Sperling. A negative run and penalty set the Knights back as they attempted a field goal. A delay of game pushed the Knights back, causing Durkin to miss the field goal, keeping the game at 24–14.

Nathanial Vakos nailed a 41-yard field goal at the end of the third quarter, making it a one-score ball game for the first time since the first quarter.

Early in the fourth quarter, the Eagles got the ball back with all the energy they needed, as DeTillo continued his fantastic game on the ground, going for his 3rd rushing touchdown of the game. Vakos hit the extra point, tying the ball game at 24–24.

Hoban took their time and used their run attack that had been effective all game to drive down the field to set up Sperling for a 15-yard rushing touchdown. The Knights took the lead with 1:47 left in the fourth quarter, 31–24. Hoban was able to hang on for the win. Once again, so close for Avon but so far.

An Avon Eagle pays the price for a first down. *Julie Spisak Herzog.*

Cold nights make for great football. *Julie Spisak Herzog.*

Shawn Purnell catches a long touchdown from Jayvian Crable. *Julie Spisak Herzog.*

Hoban moved on to the state title game in Canton for the fourth time in five years, where they faced Winton Woods and were defeated. That evening in Parma, however, against Avon, Lamar Sperling continued his fantastic playoff campaign with a stat line of 29 carries, 280 yards and 2 touchdowns as he was the man of the hour at Byers Field. Do we get this matchup once again on Black Friday 2022? Only time will tell, but I wouldn't bet against it.

CROSSTOWN RIVALS

Rocky River vs. Bay Village

People know about schools like Massillon, St. Ignatius, St. Edward, Hoban and Avon. There is no disputing that. But what most people don't realize is that one of the best and oldest high school football rivalries takes place between two tiny suburbs just miles apart on the west side. Bay Village and Rocky River High Schools are only ten minutes apart, and the intensity of the feud is so thick you can almost cut it with a knife.

It's an old-school SWC rivalry that has carried over into the current-day Great Lakes Conference (GLC). The Pirates of Rocky River and Rockets of Bay Village—two tiny schools in small but passionate communities with extremely loyal fan bases.

These kids are talented enough to play for schools such as St. Edward and St. Ignatius. Based on the fact that they live in Bay Village and Rocky River, it is safe to say finances wouldn't be an issue. But they choose to stay local and play for their hometown teams. That, to me, speaks volumes as to why this rivalry is so darn good and special.

Bay Village head coach Ronnie Rutt grew up in Bay Village and actually attended all thirteen years of school there before graduating and heading off to college. He was a three-sport athlete, excelling at football, basketball and track. He was hired right out of college and began teaching and coaching in the Bay Village school system.

Ronnie Rutt had this to share about his desire to be a part of the Bay Village culture:

At this point, I don't think I would even want coach at any other school. Bay is a special place to me. I grew up in the Bay Village school district, and I have spent my entire professional career as a Rocket. I feel very fortunate to have spent my life as a Bay Rocket, and I am very thankful for the years' and years' worth of special relationships that I have create in this district.

As a former athlete, Rutt knows the importance of good coaching. He had this to share:

As someone who learned a lot from my coaches growing up, I know the importance a coach can play in a young person's life. So, it is certainly not something I take for granted. I just try and be myself around the kids. I want all players to feel welcome and loved within our program.

I believe being a good role model is number one. But I also feel the players should know how I am going to respond to any situation that comes up. I try and be consistent in my behavior to help players feel comfortable and know what is expected of them.

Coach Rutt went on to explain why his school's rivalry with Rocky River is so important:

I think any time you have a long-standing history with an opponent, the game just means a little more. You have alumni that remember playing that school and they can share memories with the current team.

Certainly, you want the team to understand that the game means more than a normal week. Rivalry games are special and create great memories. I feel Bay and River should always stay in the same conference with each other. We are neighboring communities with similar enrollment numbers and demographics. That and our history together just makes for great, meaningful football games.

Rocky River head football coach Josh Wells grew up in North Royalton, Ohio. He had a few different sports idols growing up. At the professional level, it was Joe Montana and Mark Rypien. It was a huge deal to Wells when Rypien signed with the Browns in 1994.

He was a three-sport athlete for the North Royalton Bears, excelling at football, basketball and track. His first coaching position was as a student assistant coach at the University of Mount Union under the great Larry

Kehres. During that time, he got to learn from coaches who moved on to higher levels: Matt Campbell, Jason Candle, Nick Sirianni and Vince Kehres.

Prior to coming to Rocky River, he spent nine years at Brush High School as an assistant coach and then head coach for three years. When the position at Rocky River opened, he jumped at the opportunity and was fortunate enough to be offered the position.

Wells had this to say about the privilege and responsibility of coaching:

> *It is always a privilege to be able to coach our kids at Rocky River High School. Watching them grow into young men and reaching goals that they have set for themselves will never get old to me. I think the pressure I feel is more internal. I want to make sure each player has an experience that they will never forget playing football in our program. Making sure that we, as a coaching staff, are able to do that is where I feel the most pressure.*

This was an old rivalry in the SWC that carried into the West Shore Conference and now the GLC. It helps the overall feel and intensity of the rivalry knowing that the schools have been playing each other for so many years. Wells touched on that as well:

> *I think this rivalry is the model of what a rivalry should be. It is the first game circled on the calendar by players, coaches, parents and fans. The fact that it has been played for as long as it has makes it that much more special. We do talk about what the rivalry means, we bring in alums of the program to talk about their experiences in the rivalry series, but we try not to dwell on the past and focus on the present game in the rivalry series.*
>
> *There has been a lot of shuffling of conferences all over the area, and sometimes the rivalry games get left behind. (This just happened in the Brush versus Mayfield series.) So the fact that we are able to year-in and year-out play this game and have it be one of the big matchups for the conference is really fun for our players.*

Coach Wells would go on to explain the feeling he gets when the two teams play later in the season and when playoff seeding starts to become a factor:

> *I personally wouldn't have it any other way. Those are the types of games players live to play in, coaches want to coach in and fans love to watch. A rivalry game with playoff implications on the line, it doesn't get any better!*

Having a crowd that is so into the outcome of a game means everything to our players. They love and thrive off the support that they see, hear and feel before, during and after the game.

Their game in 2014 is the stuff of legend, as it went double overtime. Bay Village running back Nick Best had the game of his life, setting school records with 42 carries for 376 yards, including a thrilling 2-point conversion to win it in double overtime.

Bay Village coach Ronnie Rutt looks back to that magical moment:

One of the things that made Nick special was his will to win. He had a way of getting the team motivated and believing that there was no way we were going to lose to our rival. We have had some great environments for this rivalry the last several years. Both fan bases travel well for this game each year. I will never forget back in 2014 when we won at home in double overtime on a 2-point conversion and our student section rushed the field. It was an amazing environment.

Coming into the 2018 matchup, Bay Village was looking to stay unbeaten as they traveled to Rocky River during week six. The Rockets remained unbeaten with a 21–16 victory in a tightly contested game.

Multitalented Connor Shell did it all for Bay Village that evening. The senior captain finished with 126 yards rushing on 22 carries, scoring 1 touchdown. He also blocked a punt and scored on an interception. Shell was excited about the result, and he talked about it after the game. "Our line dug down on those last couple of drives and picked me up after I fumbled. I knew it was going to be close because it is a rivalry game so you can throw records out. We dug down and it was the biggest win of my tenure here. A bang for sure!"

Bay Village relied heavily on the running attack all night long and attempted just 5 passes the entire game. Quarterback Logan LaMere went 3 of 5 for 53 yards, but all 3 completions were crucial to keep scoring drives alive.

Rocky River played well and was never out of it. The key threat to the passing attack of Michael Finnegan on this night was wideout Cristian Dean, who compiled 83 yards on 7 catches. Also getting open at will was Owen Bebie, who pulled in 5 catches for 40 yards. Finnegan would throw for 171 yards and 1 touchdown on 16 of 29 passing.

Rocky River coach Wells had this to say about the performance of Shell and the Rockets, who had been tough to contain over the year: "Through my years in this rivalry, Bay has had some tough players to plan for, Shell, Nick Best, Nick Buttari just to name a few. Each one of these players had their own unique skill set that posed challenges for us to game plan against."

Rocky River received the opening kickoff and went right to work with a fast-paced, no-huddle attack. A ten-play, 70-yard drive resulted in a 33-yard field goal by Owen Bebie to give River the early 3–0 lead less than four minutes into the game. Christian Dean had 4 catches on the drive for 45 yards.

Bay Village wasted no time in responding to the Rocky River strike, answering quickly. A drive that started on the Rocky River 46-yard line was capped off with an Andrew Veverka touchdown run. The four-minute, nine-play drive saw all running plays and nothing through the air. Four different Bay Village players toted the rock on the drive.

The ensuing Rocky River drive fizzled out, and Bay Village capitalized by blocking a punt and taking over at the River 34. On the block was Connor Shell. Bay Village couldn't capitalize, and they missed a 39-yard field-goal attempt a few plays later.

The Rocky River momentum was short-lived. Connor Shell picked off a Finnegan pass and returned it 14 yards to score. Shell was making his presence felt early and often in this one. A quarter and a half into the game, Shell had a blocked punt, an interception for a touchdown and nearly double-digit tackles. Shell had also carried the ball 7 times at that point.

With less than three minutes to go in the first half, the Rocky River Pirate attack had a lot of yards to pick up, and they did exactly that. They used an exciting combination of rushes with Daishaun Hill and Ross Hartman to get deep into Bay Village territory. They elected to go for it on fourth and goal from the 2 with nineteen seconds left. The gamble paid off with a 2-yard Hartman touchdown run, cutting the lead to 14–10 at the half.

Halfway through the fourth quarter, neither team had scored in the second half when Rocky River took over in their own territory. A promising drive was soon snuffed out after crucial penalties and sacks that took them out of field-goal position. River had driven to inside the Bay Village 30 when 3 straight sacks and 2 personal fouls created a fourth and 43.

It would cost Rocky River big. On the next drive, Bay Village used a long, methodical drive to ice the game. An 8-yard touchdown Shell sprint put it away for good. A last-second Rocky River touchdown proved to be too little, too late.

Coach Rutt touches on the importance of the game being later in the year, and also the night his star player Conner Shell had:

I do enjoy the game being later in the year. At this point both teams have developed into who they are as a team. We get good film to study, and it makes for a good, meaningful football game.

Connor was a tremendous football player. He did it all that night. I remember him being gassed at times during that 2018 game, but he just kept fighting and wanted to be the one with his hands on the ball to carry us home at the end of that game. Also, that pick six was a huge play in that game.

Despite the loss, Rocky River ended up joining Bay Village, as both made playoff runs. In fact, the Pirates knocked off top seed Clyde in the opening round. Coach Wells reflects on that special group of Pirates:

That group was special! A lot of them played varsity as freshmen and sophomores, and 2018 was a special year. While we did lose to Bay that year, we were able to go into the playoffs and upset the number-one seed Clyde on the road for one of the biggest games in the history of our football program. That group, which also included freshmen Tommy Bebie and Braedon Spies, was so fun to coach, they loved playing with and for each other.

In 2019, the Pirates had a very young team led by Tommy Bebie at tailback and Braedon Spies at quarterback to go with senior receiver Cristian Dean. They started off extremely well, 5-2, heading into the game against Bay. It looked as though River would get a chance to turn the rivalry back in their favor, as they carried a lot of momentum into that game.

It wasn't meant to be for the Pirates, despite playing at home for the second straight season. The Bay Village Rockets excelled in all three areas of the game to put away archrival Rocky River, 34–17, in the Pirates Cove.

It was a big night in every phase of the game, as they ran the ball great, had a huge passing play, a blocked field goal, turnovers on defense and did the things a championship team needs to do in a big game.

The workhorse was speedy tailback Nick Buttari. This five-foot, eleven-inch, 175-pound speedster ran for a whopping 205 yards on 33 carries. He scored twice, including the touchdown that put the game away late in the fourth quarter.

Bay Village do-it-all player Connor Shell. *Author photo.*

Perhaps the even bigger star was fullback Joe Galati, who had an incredible night, creating large holes for Buttari to run through. Galati did more than just block, though. He piled up 62 yards on 9 carries, also scoring once. Galati hauled in 2 catches for 15 yards while he was at it.

The man lighting the fire for the Rockets was quarterback Logan LaMere. He didn't have to throw much, but when he did, he made it count. LaMere finished with 80 yards passing on 3 of 6 attempts with a game-changing 66-yard touchdown strike to Jake Martin.

For the Pirates, it was all the names that Rocky River fans have come to know and love doing the bulk of the work on offense. Pirate quarterback Braedon Spies looked sharp at times and showed his age at other times. Braedon finished with 145 yards and 1 touchdown on 10 of 23 passing with 1 interception and a 2-point conversion. It must be noted that he did extremely well with his legs in the second half. For the game, Spies ran for 84 yards on 9 carries.

His usual suspects were once again in full force, as Cristian Dean caught 4 balls for 55 yards while coming up with several big plays on defense and special teams. Owen Bebie had perhaps the biggest Pirate night, with 96 yards on 8 catches with 1 touchdown and a 2-point conversion. His younger

brother Tommy was somewhat held in check at times, but he erupted for 74 yards on 20 carries and 1 touchdown.

Bay Village coach Ronnie Rutt touches on why his team met with such success that night:

> In 2019 we had a tremendous defense. They carried us all season. We were able to make the 2019 our style game, great defense and a tough running game on offense. Our defense had some big plays against a great River offense in that game.
>
> As for Joe Galati, Logan LaMere and Nick Buttari, those three were super close with one another, no one cared who got the credit. Logan was a smart football player. He made a huge touchdown pass on a broken-play scramble in that game. Logan then sealed the game with a design quarterback run on a big fourth-down conversion. Joe Galati was a football player.

The Pirates went on to lose their last two games and finish the season at a disappointing 5-5. Coach Wells explains the ups and downs of the 2019 season:

> [The year] 2019 was a very interesting year for our program. Coming off the big playoff win against Clyde, we had high hopes to continue that success. We knew we would be really young in some key positions on both sides of the ball but had players like Owen Bebie and Cristain Dean, who had a lot of experience that we were hoping to rely on.
>
> The 5-2 start was great, and we were confident in our groups, but once week eight hit and we had a stretch of Bay, Buckeye and E.C., it was a test to see who we really were that year. We went into that game against Bay thinking we had what it would take to win that game but ultimately came up short. We ran into some injuries, and our inexperience really showed in the Bay game and the two that followed.

Both teams got off to red-hot starts with touchdown runs, storming down the field with no problem. Bay Village opened with a 2-yard touchdown run by Buttari on a six-play drive in which he touched the ball on five of the plays.

River answered with a 3-yard Tommy Bebie touchdown run on their opening possession to cut the lead to 7–6, as Owen missed the extra point.

The game stayed 7–6 until a wild flurry of points concluded the final five minutes of what became a fast and furious end to the second quarter.

The Rockets extended their lead to 13–6 with a 1-yard quarterback sneak by LaMere.

Then, when it seemed as though they might try to run out the clock in the first half, they stunned River with a beautiful 66-yard pitch-and-catch from LaMere to Jake Martin to score again when no one saw it coming. That touchdown drive was set up following a tipped ball from Spies that led to the pick.

The Pirates were down, 20–6, with less than ninety seconds to go in the first half when Spies led them on a well-executed two-minute drive to score.

Spies performed brilliantly on the drive and capped it off with a rocket-armed 36-yard over-the-shoulder missile to Owen Bebie to score.

Moments later, the same two hooked up on the 2-point conversion cut it to 20–14 at half. It was a crazy first twenty-four minutes that saw the Pirates pull off a fake punt as well.

A rather calm third quarter saw the Pirates cut the lead to 20–17 heading into the final twelve minutes. From there, it was all Rockets. Their ground game took over. They pounded it in again. This time, it was Galati extending the lead to 27–17.

The Pirates had a chance to cut it to 7 with a little over five minutes to go in the fourth quarter, but a Bebie field-goal attempt was blocked. From there, the air was let out of the stadium, and the second touchdown of the night by Buttari ended it for good.

Despite the loss, Coach Josh Wells talks about the experience gained on the night for his squad:

Experience playing under the lights, in my opinion, is the best thing for a young player. Tommy and Braedon got a lot out of that year, but so did guys like Charlie Sobol and Aidan Coyne on the offensive and defensive lines. I feel what they learned that year led to the success that we had in the 2020 and 2021 seasons, going 16-6, winning a conference championship, and going 3-2 in the playoffs, stemmed from the experiences in the 2019 season.

There was no 2020 edition because of COVID-19, so the Pirates had to wait even longer to get revenge against their rivals, but they did just that in 2021 with a 41–10 thrashing of the Rockets. Perhaps even more stunning than the blowout was that all 41 Pirate points were scored in the first half, as they chose not to throw the ball a single time.

On the legs of the Bebie brothers, Tommy and Johnny, the Pirates ran all over the Rockets from start to finish. Tommy finished with 247 yards and 4

Rocky River helmet. *Author photo.*

touchdowns, all coming in the first half. Younger brother Johnny went for 89 yards and 2 touchdowns. The Pirates rode the momentum of that night to win three playoff games later that fall and capture the GLC championship.

Coach Wells reflects on the big win over their rivals and how it sparked an incredible finish to the season:

> *This year's game had a lot of added juice to it for the fact that we were not able to play Bay in 2020. The Bebies and Spies were so determined to win that game and bring the Helm Trophy back to River that nothing was going to stop them. We did not go into that game thinking we wouldn't throw a single pass, but we also approach each week that we are going to take what the defense is going to give us, and it just played out that we didn't need to throw.*
>
> *Our O-line was an experienced group of young men who took pride in having our running backs run for as many yards as they did. Having Tommy, Johnny and Braedon certainly helps that, but without the bigs up front, our run game wouldn't be what it is.*

FRIDAY NIGHT TOUCHDOWN

Even when the last snap has taken place, the Friday night action is long from being over, thanks to Northeast Ohio's top place to get all the highlights. *Friday Night Touchdown* can be seen every Friday night on Fox 8 starting at 11:00 p.m. If you're a writer like me, or just a fan, it's one last taste of football nirvana to end your Friday.

Each and every Friday night, I post my article, grab some fast food and settle in for *Friday Night Touchdown*. The current version is hosted by longtime legend John Telich, P.J. Ziegler, Ken Carman and the "Commissioner," Danny Coughlin. It features highlights from twenty of the area's top games and is the absolute perfect way to cap off your Friday.

Show host John Telich grew up in Euclid, Ohio, where he graduated high school in 1971. He idolized sports heroes such as Jim Brown and Rocky Colavito. He also looked up to Jim McKay, longtime voice and main commentator of ABC Olympics coverage. His father, John Telich Sr., a track-and-field standout at Western Reserve University, also made a profound impact on his life.

After graduating college and working in smaller markets for four years, doing sports in Rapid City, South Dakota; Cedar Rapids, Iowa; and Buffalo, New York; Telich returned home to work for Channel 8 in September 1980. It was actually a CBS affiliate at the time.

Longtime and deceased Cleveland personality Casey Coleman and Telich cohosted the early version of what is now *Friday Night Touchdown*. In the 1980s, they did a taped, half-hour show that aired on Sundays, right before the blockbuster *NFL Today* show on CBS.

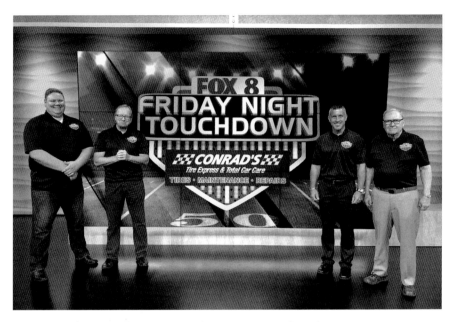

The team of *Friday Night Touchdown. Nicholas Kovach/WJW-TV.*

They covered Friday night games, and they had some Saturday night games as well, which had them writing and editing late on Saturday night and recording in the studio at 1:00 a.m. on Sunday morning. The hard work and dedication to their craft paid off for Telich and Coleman. The show got fantastic ratings. This proved that there was a passion for high school sports in Ohio.

The modern concept got its conception twenty-six years ago, when Tony Rizzo joined the team. At that time, what is now Fox 8 decided to expand the time allotted for sports on the standard 10:00 p.m. broadcast with Tony Rizzo, John Telich, Danny Coughlin and Danny Jovic. Because of the growing popularity and demand, the segment evolved into its own half-hour show. In 2013, it grew again, with P.J. Ziegler joining them after Tony Rizzo departed. In 2018, it was Ken Carman from 92.3 The Fan joining the show, making up the current format of Carman, Ziegler, Telich and Coughlin.

The show is incredible, but like anything great, it doesn't come easy. John Telich speaks about some of the challenges:

> *Nick Kovach, our awesome producer, coordinates the schedule. That's a huge challenge. Weather plays a part. He has to have backup plans, especially if Sky Fox, on a rare occasion, can't fly. The name Friday Night Touchdown*

is an equal homage to a helicopter touching down and a football play that results in a touchdown.

Another challenge is if camera people are at a game and not much happens. Nick has to adjust on the fly. He is amazing. I don't know how he has a full head of hair. He also has to watch the timing of the show. It's hard to pack soooo much football into a thirty-minute show. We joke at each first commercial, when Nick asks us in our ears, how much we think the show is heavy on time. He's always scrambling.

When you have been doing this as long as John Telich has, it comes with plenty of rewards as well. He talks about some of them here:

We get weekly feedback from so many who say they love the show. It's so gratifying. Coaches telling us how they race home to watch or go to an establishment and ask them to put the show on. People see we have fun. We also are big sticklers for getting the player's name right so we can say their name on air. It's like the old days when you bought extra papers because your kid's name was in the paper. It works. We aren't always perfect, but we really care about the details.

Football is ingrained in our culture here in Northeast Ohio. It's multigenerational. And people really know the game....It means a lot to them, just like the Browns do.

As you've seen in this book, the high school football community is a tight-knit, happy family. So many faces and names go unnoticed but make an impact all the same. Telich shares a few that have made giant impacts during his time covering Friday night lights:

Chuck Kyle is a huge favorite and very classy. I have known him since he took the job, and I highly respect him.

Tiger LaVerde at Kirtland left a desk job in Pittsburgh and pursued this. Big-time winner and a great, great teacher, as is Kyle over at Ignatius.

Ted Ginn Sr. has changed lives. He gets kids who have real tough backgrounds. He is a great mentor. He loves those kids like sons. The list of guys who turned their lives around because of him is pretty long.

All coaches get from me the ultimate respect. As for the players, all the greats...Desmond Howard...Robert Smith. Mike Doss. Maurice Clarett, Mitch Trubisky, Kareem Hunt...so many great players. Great thrills to cover them all.

Telich went on to talk about some of his favorite rivalries and finishes over the years:

In 1990, St. Ignatius beat my alma mater, Euclid, and Robert Smith in the playoffs at BW. The Wildcats converted a third and 18 with the "Immaculate Reception." They came back to win and to go on to achieve more glory.

The 1994 Massillon versus McKinley game, their 100th game with a final score of 42–41 with the Tigers winning.

Mogadore beat St. Henry in the state D6 title game, 61–58, in triple overtime, I believe. Chuck Moore, the future Mount Union star, was a beast that day. He rallied Mogadore from a 35–9 halftime deficit. Dan Coughlin was there for us that day and was speechless. I believe that prompted the OHSAA to change title game schedules to both Canton and Massillon sites so one game run over would not affect the next game on the schedule.

…

Great rivalries are usually cases of familiarity. Neighborhoods might share kids from each school. When I grew up, several of my friends played for St. Joes and other friends were Euclid Panthers. Families might be split up. Akron Hoban and St. V., and of course St. Ed's versus St. Ignatius, is the best-known such rivalry. And the bragging rights are up for grabs for the next fifty years.

John Telich retired in February 2022, but don't worry fans, he will return on Friday nights in the fall to do the show. It is that addicting! And while Telich can count on warm nights in late August and early September, we all know the weather can turn quickly here in Northeast Ohio. Telich had some fun stories to share on that note:

One week in 2021, we started at Euclid High when Benedictine was playing Erie Prep. Lightning…have to pause forty-five minutes due to weather. Waited a bit. Every second counted. Saw on Twitter, Kirtland was actually playing. Hopped in car and raced there…storm approaching.

We get to the field, shoot one play and, Bam!, lightning. Everyone clears out. Okay. We call Nick, and he says, "Head to Lakewood Stadium." Buckeye and Rangers had waited out their delay. Things were clearing a little. 8:47 p.m., they begin play. We shot ten minutes. Raced to car and called Nick, "Go to Rocky River," as Glenville was facing the Pirates. That game started a little before Buckeye and Lakewood. We race there and arrive at halftime. Darn.

Halftimes are twenty minutes. That kills us, especially so late that night due to weather. We could not wait. Raced to I-90 and promptly were stuck in bumper-to-bumper. Did not arrive at station until 10:30 and still had to write and edit the highlights we shot. I don't have as much hair as Nick, and nights like that are why.

Here's the thing—and this is coming straight from the heart: if it wasn't for *Friday Night Touchdown*, I truly do not think I would have the passion for high school football that I do. It sparked something in me that I couldn't shake. The more I watched, the more I wanted to be a part of it. It becomes a healthy addiction to want more and more. Nothing makes me happier then knowing how tight their crew is and how much they enjoy what they do.

John Telich had this to share about that closeness and what makes the show so special for the thousands who watch it:

Our place is like a big family. I love all my teammates. Danny, Kenny Carman…P.J.…and especially Nick, who puts so much extra work weekly to come up with the best game plan. He's our Super Bowl–winning coach. Our camera folks and editors are amazing. It's the ultimate example of how every detail matters. We have won some Emmys and are very proud of those, but believe me, every year we put on an Emmy-worthy product. It's one of the best franchises at Fox 8. I am so blessed to be on it and remain a part.

Guest hosts have all been amazing. Jerod Cherry, three-time Super Bowl champ. Tracy McCool. Tony Rizzo came back for an encore. There are so many and it was fun to have them in. Can't list them all. We've had Browns players who might be at a game and we involve them but have not had one in studio. I enjoy the occasions I am sharing a sideline with Bernie Kosar, who is a big fan of the show. Love talking to him about strategy, in between the occasions when fans come up and want a pic with him.

Ken Carman grew up in Canton and loved sports. His idols included Bernie Kosar, Deon Sanders, Dan Marino, Michael Jordan, Albert Belle and Kenny Lofton. He played football for Perry High School—no, not Massillon Perry—where he participated in the track-and-field program. He eventually graduated from Akron and went on to a career in broadcast journalism.

He joined 92.3 The Fan in its infancy in 2010, and because of his work ethic and immense popularity, his night show from seven p.m. to midnight

became one of the most popular in town. From there, he got moved to the important morning slot and has been a staple there ever since with cohost Anthony Lima.

Carman has risen through the ranks to become one of the most trusted voices on the Cleveland Browns, Cleveland Cavaliers, Cleveland Guardians and, now, high school football. Carman joined the crew of *Friday Night Touchdown* as a guest host in 2018 before becoming a regular in 2019.

Ken has a great theory on why high school football has become so popular in Ohio:

> *The easy answer is to say the Pro Football Hall of Fame, and while that's great, I think it's a lot deeper than that. Ohio's history is mixed with agriculture wrapping around a good list of larger cities. You have very proud small towns, and then you had a large immigrant population coming to cities from the early 1800s on. Football is the perfect sport for communities to argue who is better.*
>
> *To highlight the comparison, Ohio has five cities that have populations over 150,000. Indiana has two. Ohio has fewer farm towns.*
>
> *Corn and soy are harvested in September...the main time for football season. It's not surprising that Ohio has a strong football history, while Indiana needed their teenage boys for harvest time, making basketball more important.*

When asked about who he has met in the industry that have left lasting impressions both on the field and off, Ken wasn't shy from handing out the praise to his former coach Keith Wakefield of the Perry Panthers. He also feels that Head Coach Chuck Kyle of St. Ignatius remains the gold standard. He didn't want to list any in the book for fear of leaving some out. We completely agree, and that's what makes writing books like this tough, as it could easily be five hundred thousand words and five hundred pages and still leave a lot of people out.

When asked about the greatest finish Carman ever watched, his choice was one that would be on most fans' lists:

> *When I was a kid, Canton McKinley versus St. Ignatius at the Rubber Bowl, state semis 1997. Ignatius led the whole game, really dominated it, and then with about six minutes left, McKinley made a comeback. With about forty seconds left, Ben McDaniels threw to Fred Wilcox, who had it tip off his helmet, and Matt Curry caught it and ran it down to the 1.*

McKinley scored with thirteen seconds left, won, 20–19, then went on to beat Moeller in the state title game.

Carman would list these five as his top high school rivalries:

1. McKinley - Massillon
2. St. Edward – St. Ignatius
3. Martins Ferry – Bellaire
4. Xavier - Elder
5. Dover – New Philly

Ken has been such a tremendous addition to the *Friday Night Touchdown* team. His passion and knowledge are felt through every highlight he calls and every hot dog stand he appears at to film fun sketches with the boosters. He is just a fantastic person all the way around and has become that voice I start my day with on Fridays—and now end it with as well.

For Ken, the privilege is not lost on him, and he shows it nothing but respect. He had this to share:

> *Working with Danny, John and PJ has been a dream. PJ and John have answered every question I've ever had and have taken great care of me to not let me embarrass them on tv!! Danny is so different because I think he might be the last real connection to the way things used to be. John, has a ton of experience but there's almost 30 more years than Danny has over all of us. Danny covered pro teams when there was a real relationship between writers and teams. Players lived in the same neighborhoods as writers and regular fans. Danny is such a great storyteller, he's able to take you back to that time and show me what it was really like during a period of time that I don't think we'll ever see again.*
>
> *As far as high school sports, Danny can tell us what the rivalries were like in the old neighborhoods, and even highlight old rivalries that have went dormant. My generation can bring up the Golic's (because our family members told us) and we saw Ted Ginn, etc., but Danny is so great at telling tales of some really great players that just went on to college, or the military, or work and had normal lives after.*

There is a reason they call Danny the "Commissioner," and that fact was not lost on Carman.

EPILOGUE

L egacy, tradition, brotherhood! Three words that sum up my own personal love of high school football. From the time you exit your car and hear that first marching drum play, until the time you go to bed that night, your heart is racing and momentum is pumping through your veins. There are few greater feelings than being underneath those bright lights on a Friday night as the community watches.

The last few years have been different, much different. The community is no longer there in droves. In 2020, only one band was in the stands, and sometimes you only heard them at halftime. People were forced to wear masks, so those roars aren't quite the same. However, the one thing that never changes is legacy, tradition and brotherhood. I don't care if there is one person in the stands or ten thousand people. It doesn't change!

I hope everyone has enjoyed this book. I could go on and on with one example after another, but I think after fifty-five thousand words, you get my drift. Football is more than a sport. It is much more.

It gives these kids a reason to work hard, stay off drugs, focus in school and know they can have a better life one day. I've said it for years: it's more than a game. For some families, it is their first and only chance to smile during hectic and stressful weeks.

Legacy, tradition and brotherhood!

FOOTBALL BEST-OF LISTS

Ohio's Oldest and Longest Football Rivalries (1878 to 2020)
1. Cincinnati Hughes vs. Cincinnati Woodward (1878)
2. Massillon vs. Canton McKinley (1894) ; Lorain vs. Elyria (1894)
3. Cincinnati Hughes vs. Cincinnati Walnut Hills (1895); Sandusky vs. Fremont Ross (1895)
4. Dover vs. New Philadelphia (1896)
5. Troy vs. Sidney (1897)
6. Fostoria vs. Findlay (1898); Jackson vs. Wellston (1898)
7. Troy vs. Piqua (1899) ; Bellefontaine vs. Sidney (1899) ; Bellefontaine vs. Urbana (1899) ; Portsmouth vs. Ironton (1899)
8. Bowling Green vs. Napoleon (1900); Napoleon vs. Wauseon (1900); Fostoria vs. Tiffin Columbian (1900)
9. Newark vs. Zanesville (1901); Ashland vs. Wooster (1901); Findlay vs. Marion Harding (1901)
10. Dover vs. Coshocton (1902); Findlay vs. Fremont Ross (1902)
11. Orrville vs. Wooster (1903)
12. Bellaire vs. Martins Ferry (1907)
13. Ravenna vs. Kent Theodore Roosevelt (1911)
14. Dover vs. Cambridge (1914)
15. Dover vs. Wooster (1915)
16. Defiance vs. Van Wert (1916); Defiance vs. Napoleon (1916)

Ohio's Oldest and Longest Football Rivalries
(Through 2021 season)
1. Cincinnati Hughes vs. Cincinnati Woodward (1878), 143 games
2. Troy vs. Piqua (1899), 137 games
3. Massillon vs. Canton McKinley (1894), 132 games
4. Portsmouth vs. Ironton (1899), 130 games
5. Doylestown Chippewa vs. Rittman (1923), 122 games
6. Dover vs. New Philadelphia (1896), 118 games; Bellaire vs. Martins Ferry (1907), 118 games
7. Sandusky vs. Fremont Ross (1895), 116 games; Newark vs. Zanesville (1901), 116 games
8. Orrville vs. Wooster (1903), 110 games
9. Lorain vs. Elyria (1894), 107 games

Information was researched and updated on December 1, 2021, by Dover High School Crimson Tornado biographer Dennis Wilson Rubright and includes the 2021 football season.

Ohio High School All-Time Football Wins
1. Massillon (920-297-36)
2. Canton McKinley (859-366-42)
3. Steubenville (836-329-34)
4. Cincinnati Wyoming (737-221-48)
5. Dover (719-373-44); Martins Ferry (719-393-36); Cleveland St. Ignatius (719-324-32)
6. Warren Harding (718-454-49)
7. Ironton (714-360-45)
8. Sandusky (707-413-36)
9. Piqua (706-435-48)
10. Bellaire (702-386-53); Fostoria (702-483-42)

ABOUT THE AUTHOR

Vince McKee is the author of eleven published books and is the CEO and founder of Kee On Sports Media Group. The company is the leader in Ohio high school sports coverage and broadcasting.

McKee is a respected member of the high school football scene and has covered over twenty state championship games since entering the business in 2015.

He has been published in book form ten previous times, with copies of his work sold all over the world. He has been featured on over twenty-five local radio programs as well as broadcast television, ESPN, Sports Time Ohio and Ballys Sports Ohio, as well as several other news outlets for his previous work.

McKee travels the state giving motivational speeches about his start and experience in the business. When he is not calling or covering games, he is an avid pro wrestling fan. His favorite thing to do is spend time with his wife, Emily, and daughters, Maggie and Madelyn.

If he is not watching sports, you will catch him watching documentaries about sports or the Food Network with his wife. As an avid Cleveland sports fan, he is living the dream, as he has interviewed almost every one of his sports heroes from the 1980s and '90s.

He can be reached via email at coachvin14@yahoo.com and Twitter @SportsKee1.